Cycladic Art

J. LESLEY FITTON

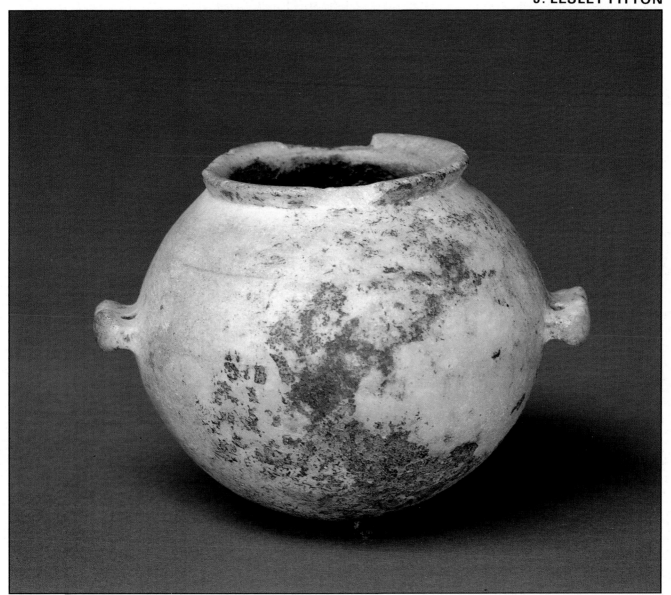

HARVARD UNIVERSITY PRESS
Cambridge, Massachusetts
1990

Front cover Detail of the head
of a figure of Early Spedos
type, with traces of black and
red paint on the face and neck;
Keros-Syros culture, about
2700–2500BC.
(GR 1971.5–21.1)

Back cover Full-length view of
the Early Spedos figure shown
on the front cover.

Inside front cover
Landscape on the island of
Naxos.

Title page Marble spherical pyxis
(box) of the Keros-Syros culture
(about 2700–2200BC). The lid
is missing, but could have been
held in place with string
running through the double
lugs. (GR 1955.4–19.1)

This page Evening on the island
of Syros.

For my parents

Contents

Introduction

The period between about 3200BC and 2000BC saw the flowering of a remarkable and distinctive culture in the Cyclades. Scattered in the middle of the Aegean sea, many of these small rocky islands are practically made of marble, and it is marble objects – vessels and, in particular, sculpted figures – that are amongst the most characteristic products of this culture. Today Cycladic figures are known and admired throughout the world and are the treasured possessions of museums and collectors, as they must have been treasured by those who made and used them in remote antiquity. Yet these simple sculptures, usually female and naked, with arms tranquilly folded and austere backward-tilted heads, retain an air of mystery. They wear nothing, hold nothing, and scarcely have facial features; in fact, they give almost no clues as to why they were made, or who or what they represent.

In spite of this, they are not 'inhuman'. Their scale is approachable (though some are quite large) and the tactile quality of the smoothed marble attracts the hand, even as the simple forms and pure lines of the figures attract the eye. They are 'works of art' to us, perhaps, but they were not made to be seen in a glass case. Most seem to have been the personal possessions of their original owners, kept by them in life and accompanying them to the grave in death, and they retain some sense of this intimacy.

The products of a prehistoric society are difficult to interpret, since by definition no written records exist to help. Nonetheless, archaeology, through painstaking excavation and analysis of the material remains of the past, can give us information with which to build a picture of early societies. The period to which the Cycladic figures belong is now recognised as the Early Bronze Age in Greece, specifically referred to as the Early Cycladic period in the islands. The approach to a better understanding, both of Early Cycladic sculp-ture and of the other products of this culture, must lie in the attempt to put them back into context, and view them against a background of all we know about the life and times of the people who made and used them. Naturally the picture remains incomplete, perhaps frustratingly so: after four and a half thousand years it could hardly be otherwise. Nonetheless, much is known, and with the progress of archaeological research further information is gathered year by year.

The aim of this book, then, is to discuss the rich and varied collection of Cycladic objects in the British Museum in the context of our current knowledge of the Early Cycladic period – roughly the third millennium BC, when the island culture was particularly original and distinctive. The collection is remarkably comprehensive, including not only a fine range of marble figurines and vessels, but also many items of a more workaday nature, such as metal tools and obsidian blades. The pottery ranges from simple, undecorated types to very elaborate painted vases, while more unusual items include silver jewellery and a figurine 77. 76 made of lead. The collection as a whole therefore provides the basis for insights into many different aspects of Early Cycladic life.

1 The history of exploration

I had been opening the graves of the prehistoric inhabitants of Antiparos for some days, and was getting weary of this sexton-like kind of life . . .

JAMES THEODORE BENT

'Rude', 'grotesque', 'barbaric', even 'repulsively ugly' – such were the epithets that greeted the first Cycladic figurines to find their way abroad in the baggage of travellers from western Europe in the first half of the nineteenth century. Both figures and marble vessels were collected as curiosities at that time, and it was in this spirit that several pieces now in the British Museum were brought to England by or for early collectors. The latter included such notable figures as Thomas Burgon and the sixth Viscount Strangford, along with others whose collections were much better known for objects of later (and they would have said finer) periods, but who were sufficiently intrigued by the prehistoric pieces to include a few of them as well.

While the thoroughly accepted 'Classical' ideal of beauty in marble sculpture precluded all but the most damning of aesthetic judgements, Cycladic works were nonetheless the subject of a degree of academic curiosity. They were recognised as 'primitive' and therefore considered to be early, but with no knowledge of Greek prehistory their real age could scarcely be guessed, and was greatly underestimated by those who dared to try. Only with the development of the new discipline of archaeology, and particularly with the excavations of Heinrich Schliemann at Mycenae (begun in 1874), did the existence and extent of the prehistoric period in Greece begin to be recognised and some sort of chronological context for the Cycladic objects begin to emerge. Writing as early as 1878 Charles Newton, Keeper of Greek and Roman Antiquities in the British Museum, was able by an inspired piece of reasoning to work out that the Cycladic pieces predated both the Mycenaean finds from Mycenae itself and those from the island of Rhodes, which had reached the Museum some few years earlier.

Such early insights began the process of understanding the period that came to be called the Greek Bronze Age, when the Cycladic, Minoan and Mycenaean cultures flourished. Since the existence of civilisations earlier than that of Classical Greece had not previously been suspected, the process was necessarily a slow one, and even now information from new excavations can considerably alter the picture year by year. It is therefore not surprising that Newton, in the very early days, got some things wrong. In fact, the absolute date he arrived at for the Mycenaean artefacts – about 1100BC – is now known to stand at the very end of the Mycenaean period, and though he was not so specific about Cycladic figurines, describing them only as 'perhaps even more ancient', it is clear that he was underestimating their age by up to a millennium. Several decades were to pass before increased knowledge enabled more accurate estimates to be made.

The first systematic excavations in the Cyclades were carried out by an Englishman, James Theodore Bent, who travelled in the islands in 1883 and 1884, when they were still isolated and rarely visited by foreigners. Bent's interests were not purely archaeological: he was essentially an explorer who travelled in various little-known parts of the world with his equally adventurous Irish wife, Mabel. He published an account of his island journeys in a work entitled *The Cyclades, or Life among the Insular Greeks*, a fascinating account of island life, customs, folklore and history. The Bents certainly saw Cycladic life at close quarters, since, as Bent himself noted, 'There are twenty-two [inhabited islands] . . . and only two of them have anything like hotel accommodation.' This meant that he and his wife stayed in the homes of their island hosts and relied heavily on their hospitality. The islanders seem to have been characteristically generous with all they had, including information. This was of inestimable value to Bent, and it was perhaps for this reason that he

could make a rather surprising statement: 'In every island ... on almost every barren rock, I might say ... are found abundant traces of a vast, prehistoric empire.'

This assessment seems remarkable to the average modern visitor, since it is perfectly possible to be in the Cyclades and yet to have almost no awareness of the prehistoric past. The cynic might suppose that all traces have been swallowed up in a rising tide of cocktail bars and discothèques, but even outside the newly booming tourist centres its remains are elusive. The determined traveller will discover that the sites are often remote and difficult of access, the remains small-scale and unimpressive. The islands guard closely the secret that they were the home of an important and influential early culture. Bent, though, had a rather different perspective. Not only were the islands undeveloped in his day, but also the islanders themselves, knowing the terrain in minute detail, could point out to him even the slightest remains from the prehistoric period. Some had even brought such remains home: 'In our travels we found lots of the marble figures and bowls in the peasants' houses, which they had found whilst digging in their fields.'

Bent decided to excavate on the island of Antiparos, chosen because it was near to Paros, which he thought had been the 'great centre of this [prehistoric] population', but, unlike Paros, had not been important in later times, and might therefore offer early remains without later overlay. Several cemeteries were pointed out to him by the islanders, and he opened some forty graves in two of these, with workmen provided by the Messrs Swan, who ran the local calamine mines. It is the finds from these excavations that form the core of the British Museum's Cycladic collection.

The first cemetery was on a hillside above a bay facing the neighbouring islet of Despotiko; the second in the southeastern part of the

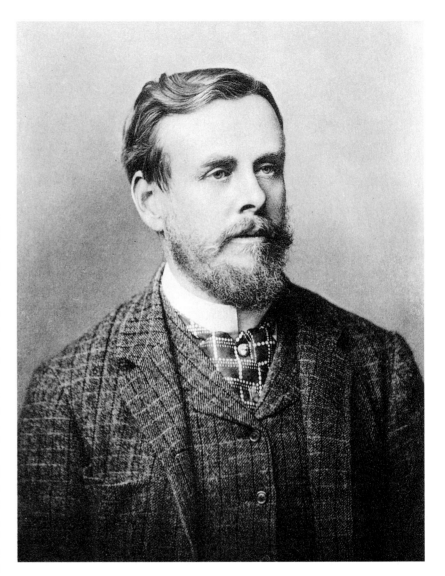

island. The first was 'greatly inferior to the other in the character of the graves themselves, and in the nature of the finds therein, though they all belonged to the same class of workmanship.' Since we now recognise that Bent's finds cover a considerable period, it seems probable that he was noticing a chronological difference between the two cemeteries.

Unfortunately his account of his discoveries, though remarkably thorough for its time, does not allow specific objects to be linked to specific graves.

Bent was a restless spirit and perhaps had not the patience for prolonged archaeological pursuits. Nonetheless, he published the results of his excavations with exemplary speed, and he certainly deserves to be credited with the first scientific exploration in the islands. He was also an enthusiast, concluding his report, 'I am convinced that a further study of this subject under a more vigorous system of excavation than I was able to bestow on it, would result in many interesting facts becoming known about this primitive race of mankind.'

Events were to prove him right, though the progress of Cycladic studies was not without setbacks, with the result that even now there are considerable gaps in our knowledge. Further excavations were carried out in the islands, most notably those of the Greek archaeologist Christos Tsountas who, in 1898–9, opened several hundred graves on Syros, Paros, Despotiko, Siphnos and Amorgos, as well as excavating the fortified settlement of Kastri, near Chalandriani, on the island of Syros. Kastri was the first Early Cycladic settlement site to be excavated. Nearby tombs were also dug by Tsountas in 1898, and some of the finds from these were given to the British Museum as part of an exchange with the Greek Government in 1912. It was Tsountas who coined the term 'Cycladic civilisation' to refer specifically to the Early Bronze Age culture of the Cyclades, the individuality of which he was the first to recognise.

Excavations were carried out in 1896–9 by the British School at Athens at Phylakopi, on the island of Melos, an important town throughout the Bronze Age. Further campaigns were conducted there in the 1970s, so that this long-lived site has been very thoroughly explored and has provided valuable stratigraphic evidence. Some finds from the early excavations were given to the British Museum, though the majority of these are Middle Bronze Age in date. One or two pieces that came from early collections, however, are said to be from Melos, and are likely to have come from tombs in the neighbourhood of Phylakopi.

While the British Museum's Cycladic collection was largely formed by the beginning of the twentieth century, excavation and research both in the islands and in neighbouring lands continued to improve understanding of the Early Cycladic culture. Arthur Evans's discovery of the palace at Knossos in Crete, where he began work in 1900, revealed to the world the glories of the Minoan civilisation, which proved from its beginnings to have been in contact with the islands. Excavations on the Greek mainland revealed Cycladic connections, particularly with the coast of Attica, while further afield the western coast of Asia Minor, too, was seen to have had contacts with the Cycladic world.

The picture thus became clearer, though there were few major excavations in the islands between the early years of this century and the early 1950s. This was partly due to the upheavals of war, and partly because the islands were overshadowed by important discoveries elsewhere, particularly in Crete. However, the situation changed dramatically in the 1950s and 1960s, which saw a great upsurge of interest in things Cycladic. This era left behind a good and a bad legacy, both of which are still very much with us today.

Renewed interest in Cycladic artefacts initially stemmed from the world of fine arts rather than that of archaeology, as perceived similarities between 'primitive' sculptures and the works of modern artists led to the former becoming popular with collectors and begin-

1 James Theodore Bent.

7

ning to command high prices. Cycladic sculpture was particularly affected: small but influential exhibitions brought it to the forefront of public notice, and the inherent attractiveness not just of the forms themselves, but also of the fine white marble of which they were made, resulted in a runaway market demand for Cycladic figurines. Not surprisingly, this caused mayhem in the Cyclades, where cemeteries which had been left untouched for four thousand years, or had only accidentally been disturbed, suddenly became the centres of illicit looting and pillaging. Graves were torn open, valuables extracted and all else discarded, leaving sites devastated and deprived of most of the archaeological information they could have given if properly excavated. Moreover, if the genuine article could not be obtained, the forgers were quick to step into the breach, and a flood of fake Cycladic figurines entered the market, further confusing the picture.

Such was the negative side of the story. On the positive side is the fact that the last thirty years or so have also seen greatly renewed archaeological and scholarly interest in the Cyclades. Steps have been taken to prevent depredations in the islands, and significant excavations have taken place. The Greek archaeologist Christos Doumas excavated a number of Cycladic cemeteries and wrote the definitive work on Early Cycladic burial customs, while other members of the Cycladic Ephoreia (the branch of the Greek Archaeological Service responsible for the islands) have also achieved notable results both by excavation and by working on and arranging the collections of the local museums. Important excavations, begun at Ayia Irini on the island of Keos in 1960 but not yet fully completed, have furnished evidence from one of the few settlement sites to be explored fully. Intensive survey on the island of Melos has provided valuable information of a different sort, addressing the wider problems of settlement patterns throughout the prehistoric period. Colin Renfrew, amongst many contributions to our knowledge of the islands, wrote the first study to bring together all aspects of Cycladic culture, while Pat Getz-Preziosi has revealed a wealth of information based on the detailed study of Cycladic sculpture. The collections of the National Museum in Athens have been studied and republished by curators there, particularly G. Papathanassopoulos, while Jürgen Thimme of the Badisches Landesmuseum, Karlsruhe, in 1976 arranged an exhibition of Cycladic artefacts which was exemplary in its approach. The catalogue has since become a sort of 'Cycladic bible'. The opening in 1986 of the N. P. Goulandris Museum of Cycladic Art in Athens provided a permanent home for the magnificent collection which has done so much to retain important Cycladic pieces in Greece, while in 1987–8 an exhibition of Early Cycladic art from North American collections, also accompanied by a fine catalogue, was held in Richmond, Virginia, and other American venues.

In spite of some difficulties, then, Cycladic studies are flourishing, and this is a good time to review the British Museum's Cycladic collection. It is fortunate that this was mainly formed at so early a date that forgeries of Cycladic objects were not yet being made; fortunate, too, that the collection is so comprehensive – quite remarkably so, in view of the fact that chance, rather than any guiding principle, played the major part in its formation. Problems arise because of the lack of specific contextual information for so many of the pieces, and an in-built imbalance exists because so much of the material originally derives from tombs. In both of these respects, however, the collection shares common ground with the great majority of Cycladic objects known throughout the world.

2 The islands then and now

Paint me a cavernous waste shore
Cast in the unstilled Cyclades,
Paint me the bold anfractuous rocks
Faced by the snarled and yelping seas.

T. S. ELIOT

2 Lead model of a ship, found on Naxos. Keros-Syros culture, about 2800–2200BC. (Ashmolean Museum, Oxford, 1929.26)

Small rocky islands pounded by the sea, covered with aromatic scrub with outcrops of marble, baked by the summer sun and lashed by winter storms – much that can be said of the Cyclades now was equally true in antiquity, and with a little imagination we can 'think away' the twentieth century and return the islands to the state in which their inhabitants saw them in the third millennium BC. The effort is worth making, not simply in the romantic spirit of trying to recapture the past, but also as part of a serious attempt to reconstruct the Early Cycladic way of life. While geography and the natural environment can never fully explain why a particular society flourished and developed in a particular way, they are nonetheless fundamental to our experience of the world and the way we shape our existence, if only because of the inescapable effects of the forces of nature.

The name 'Cyclades' means 'those in a circle', and the islands were so called by the ancients because they form a rough circle, *kuklos* in Greek, around the holy island of Delos, an important sanctuary in Classical times. The position of the group, more or less in the middle of the Aegean sea, meant that the islands formed natural stepping-stones between mainland Greece, Crete and the western coast of Asia Minor. Such stepping-stones were particularly welcome in the early

days of seafaring, when navigators tried not to lose sight of land. The Cycladic islanders of the Early Bronze Age were expert shipbuilders and sailors, and the importance of the sea in their lives is shown not only by the models and representations of ships which feature in their art, but also by the fact that Early Cycladic artefacts have frequently been found in neighbouring regions. Naturally these need not all have been taken abroad by Cycladic ships: visitors from elsewhere also came to or passed through the islands, and a few foreign imports and influences can be found. Clearly the islanders took advantage of their opportunities for trade and communications with the outside world, and this was an important element in their success.

In general, though, the Cycladic islanders seem to have exported more than they imported. The sea, although obviously a means of communication, at least in the summer months, is also an isolating factor, encouraging an independent spirit in an island people. It was perhaps because of the sea that Cycladic culture was unique. Strong traditions developed that owed little to the outside world and persisted for hundreds of years. One example is the production of marble figures: not only did the social or religious attitudes that made figurines seem desirable persist for centuries, but the skills necessary to make

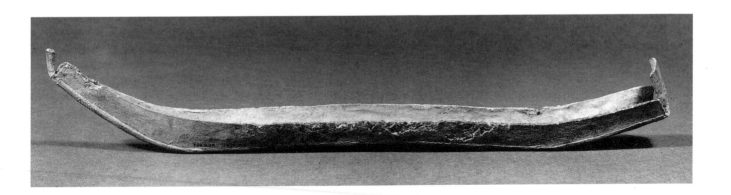

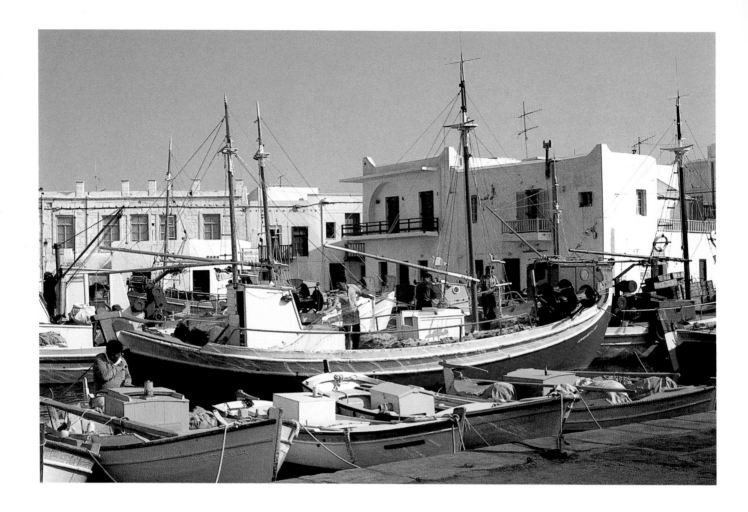

3 A modern Cycladic fishing harbour: Naoussa on Paros.

them according to certain set patterns were handed down from sculptor to sculptor over generations. Cycladic figurines and marble vessels are not only entirely characteristic products of the culture, but also far finer than the contemporary products of neighbouring lands.

The climate of the islands in antiquity was probably quite similar to that of today, with long hot summers and relatively mild though quite wet and windy winters. Winter storms can make sailing very dangerous for small boats, so presumably the navigation season would have extended only over the summer months. While the islands are rocky, most of them have some fertile land, and in the largest of them, particularly Paros and Naxos, this is quite extensive. Grain, grapes and olives, the so-called 'Mediterranean triad', seem to have become the three major crops during the Early Bronze Age, as they still are today. Sheep, goats and some pigs were kept, along with a few cattle for which the terrain was less suitable. Oxen were probably the main draught animals: it is not certain whether the donkey, now such a typical feature of the

GREECE

• Troy

*AEGEAN
SEA*

ASIA MINOR

ATTICA

Athens •

PELOPONNESE

• *Franchthi
Cave*

THE CYCLADES

Andros

Gyaros **Tenos**

Keos

Kythnos **Syros** **Mykonos**

Seriphos

Paros **Naxos**

Siphnos

Ios

Melos **Amorgos**

Pholegandros **Thera (Santorini)**

Anaphi

Rhodes

CRETAN SEA

Crete

4 Fertile land on the island of Naxos.

Cycladic landscape, had appeared in the islands at this time.

The islanders' diet could be supplemented with fish, perhaps particularly tunny which pass through the islands seasonally on predictable 'runs', as well as shellfish and probably game. Honey, pulses, milk, cheese and wine were also doubtless known to them. Nonetheless, extracting a living from the land must always have been difficult, and a high proportion of the islanders' time must have been taken up by agricultural pursuits.

Naturally shelter was also essential. A variety of building stones was available, varying from layered stones known as schists in the northernmost islands, limestone and marble elsewhere, and stones of volcanic origin on Melos and Thera. Not surprisingly, stone construction is typical of Cycladic architecture, usually in combination with perishable materials such as clay mixed with straw, and wood. Wood is not plentiful in the islands these days, but it may have been more so in the Early Bronze Age, though the islands were probably never thickly covered with trees. Wood must also have been important for shipbuilding, and tools that were probably used for woodworking have survived, including some fine examples in the British Museum (p.57).

These tools are made of native copper, and

this brings us to the metal resources of the islands. Analysis has shown that the copper ore used in these particular examples came from the island of Kythnos, which seems to have been an important (though not the only) source utilised by the Early Cycladic people. Arsenical copper was the most common alloy in the Early Bronze Age and, though some copper ores are naturally arsenic-rich, the amount of arsenic found in Early Cycladic objects seems to indicate a deliberate alloy, with a fairly well-controlled amount of arsenic being added to produce a stronger, tougher finished product. Arsenic is, however, difficult to use, being both volatile and poisonous, and it must have made the smiths' lives much easier when towards the beginning of the Middle Bronze Age tin was introduced, from sources that are as yet unknown. After this a copper and tin alloy became the most commonly used. Rather earlier tin-bronzes of the Kastri group, from Kastri on Syros, have been shown by analysis to be close in composition to Trojan bronzes, and perhaps imply the importation either of raw materials or of finished products from the area of Troy (p.57).

Silver and lead were mined on the island of Siphnos and some fine silver jewellery was produced. Lead was occasionally used to make such objects as boat models and figurines, and there is an example of the latter in the Museum's collections. Gold is not now known in the islands, in spite of later literary references to its occurrence there. It was scarcely used in the Early Cycladic period, and only one single gold bead has been found in a Naxian tomb.

Marble is the material from which the finest and most characteristic Early Cycladic objects were made, and marble is found in many, though not all, of the islands (the exceptions include those of volcanic origin). Marble from both Paros and Naxos was particularly famous in antiquity as well as in later times, and deep

quarries can be seen on both these islands. In fact, the quarries are more like mines, since the purest, whitest stone is found at the lower levels, and many are now disused as it is no longer cost-effective to extract this marble. The Early Cycladic sculptors had no such problem: pieces of marble quite large enough for their modest-sized works could easily be found lying on the surface or on the beach, where the sea had done much of the work of smoothing and polishing.

Metal tools became quite widely available in the islands at the same time as the production of Cycladic figures and marble vessels was at its height, and no doubt they were used by the sculptors. In fact, they are not necessary, as stone tools have been shown to be quite adequate (p.64). Emery, a dense heavy stone found on Naxos, could have been useful both in the form of hammers and 'chisels' (even if these were only roughly pointed chips), as well as in its more familiar form as an abrasive for smoothing and polishing. Emery may have been used in the form of a powder to help the action of simple drills, and perhaps it was

5 Entrances to the marble quarries of Paros.

6 (*Above*) A heap of emery awaiting transportation at Moutsouna, Naxos.

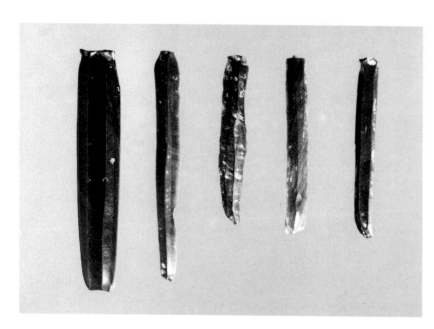

7 (*Above*) Four obsidian blades and a core from which blades have been chipped, dating from about 3000–2000BC. Found on Antiparos. (GR 1884.12–13.28, 30, 31, 36 and 37)

mixed with water to make an abrasive paste.

Obsidian, the black, glass-like volcanic stone found on Melos, can be chipped like flint to form a sharp edge. Before the introduction of metallurgy to the islands, obsidian was extensively used for blades and tools and was widely exported to surrounding regions. Since at first metal tools were very rare, and even when they became more common they must always have been valuable, obsidian continued to be used as a cheaper and more readily available alternative throughout the Early Bronze Age. In marble working, obsidian blades or flakes could have been used to cut incisions into the sculptures in order to complete their finer details. Another volcanic stone, pumice, from the island of Thera, might have been used to impart a final shine and polish to the stone.

In general, then, the Cyclades offered a reasonable range of natural resources, but required of their inhabitants a good deal of hard work, toughness and determination to benefit from them and make a living there. Beautiful and entrancing as the islands appear to the summer visitor, in the winter the village houses seem to huddle together for warmth along their narrow winding streets, much as their ancient counterparts must have done. Conditions were still fairly rugged in Bent's day, and it is hard to read his paragraph about bad weather on Thera without a sympathetic shiver:

We had a biting Northern blast for three whole days, accompanied by drifting small snow – weather such as we rarely have in England for misery; and when the only available fire is a brazier with charcoal ashes, which gives you a headache if you stoop over it, the only alleviation to your misery is to stay in bed or take exercise of an exceedingly active nature.

3 The development of Cycladic culture

Any system of classification ... is our modern attempt to describe and simplify what may have been a more complex situation, and any terminology for prehistoric peoples and their material culture is bound to be somewhat arbitrary.

COLIN RENFREW

The Early Cycladic culture, spanning roughly the third millennium BC, fits chronologically into the period known as the Early Bronze Age in Greece. The term 'Bronze Age' is used because metal-working was introduced to Greece from the more developed civilisations of the East, and first copper and then bronze was the main material used for tools and weapons. In the preceding Neolithic period (the New Stone Age), stone had been used. Bronze was later replaced by iron, and the Iron Age in Greece began about 1100BC.

The Greek Bronze Age, then, lasted from about 3200BC to about 1100BC. To give a more precise framework for reference, this long period has been divided into an Early, Middle and Late stage. In the course of time three different geographical areas, each with its own distinct culture, came to prominence. The Cyclades were the first, perhaps because they combined the advantages of a central position with the independence that an island existence encouraged. The term 'Cycladic' is used to describe the Bronze Age culture of the islands, and it is the Early Cycladic period that is the subject of this book – a time when the islands were at the hub of original and influential developments. The succeeding Middle and Late Cycladic periods, though interesting, were times when the Cyclades were much influenced by their larger and more powerful neighbours, first Minoan Crete and then Mycenaean Greece.

It should perhaps be noted that a certain confusion sometimes arises in the use of the term 'Cycladic', which is often used when strictly 'Early Cycladic' is meant. Thus Cycladic figurines and even 'Cycladic Art' (as in the title of this book) should really be called Early Cycladic to avoid confusion with the rest of the Bronze Age (the Middle and Late Cycladic periods).

While the Early Cycladic culture was flourishing in the islands, Crete, their much larger neighbour to the south, saw the beginnings of the Minoan civilisation, discovered by Arthur Evans and named by him after Minos, legendary king of Crete. During the long formative Early Minoan period, Crete felt extensive influences from the Cyclades. Cycladic products, particularly figurines, were both imported into Crete and imitated there by local craftsmen, and certain sites, particularly on the north-east coast and in the centre of the island, reveal substantial Cycladic cultural influence. This is perhaps not surprising; Thera, the southernmost of the Cyclades, is separated from Crete by only some 60 km of open sea.

Eventually the situation was to be reversed. The beginning of the Middle Bronze Age saw the foundation of the great palaces of Crete, and with the growing importance of the Minoan civilisation in the eastern Mediterranean, the Cyclades came ever more under the influence of their powerful neighbour. The islands, small and scattered, were not able to develop the sort of strong, centralised power that characterised Minoan Crete. The Late Cycladic town of Akrotiri, recently discovered on the island of Thera and miraculously well preserved under thick layers of volcanic ash, shows that the Minoan way of life had by this time become thoroughly established in the islands – though the native spirit can still be seen in much of its art.

The term 'Helladic' is used for the Bronze Age culture on the Greek mainland and, again during the Early Helladic period, influence from the Cyclades can clearly be seen. The cemetery of Agios Kosmas, on the coast of Attica, included graves of Cycladic type containing Cycladic objects, and while these may not represent a true Cycladic 'colony', there could have been a Cycladic element in the population, and there can be no doubt that cultural influence from the islands was strongly felt on this part of the Greek mainland.

Between about 2200 and 1900BC, groups of invaders came into Greece, probably from lands to the north or east. Their language combined with that of the native population to become the earliest form of Greek. The Cyclades, too, may have seen foreign incursions towards the end of the Early Bronze Age (p.37).

The Late Helladic or Mycenaean civilisation of mainland Greece dominated the Aegean region in the Late Bronze Age, taking over this position from Minoan Crete, which became part of the Mycenaean sphere of influence. With the collapse of the Mycenaean world, which took place for reasons that are not fully understood during the twelfth century BC, the Greek Bronze Age was at an end.

The Greek archaeologist Christos Tsountas took a decisive step in Cycladic research when, during his extensive excavations at the end of the nineteenth century, he recognised both the homogeneity and the individuality of the material he had revealed, and coined the term 'Cycladic civilisation' to describe the world that he had done so much to uncover. In fact, though, the word 'civilisation' is not really appropriate for the situation in the islands at this early time. Throughout the Early Cycladic period there were no towns of any considerable size, no large public buildings, no use of writing, in fact no indications of the sort of advanced and sophisticated society that the term usually implies. The word 'culture' is more appropriate, with its rather minimalist definition by the pioneer archaeologist V. Gordon Childe as 'a consistently recurring assemblage of artefacts'. As we shall see, this word is also used in a more limited sense to describe the major groups of Early Cycladic material.

The Early Cycladic period lasted for more than a millennium, and so again a framework is needed in order to provide points of reference. In fact, not just one but two different systems of classification are currently in use.

The first is based on the traditional division not only of the Cycladic Bronze Age as a whole into Early, Middle and Late stages, but also the tripartite subdivision of the Early Cycladic period into Early Cycladic I, Early Cycladic II and Early Cycladic III. This system was introduced (as was the similar system applied to the Helladic culture) following Evans's classification of the Minoan material, which he evolved while excavating the palace at Knossos. The idea was to facilitate comparisons between the three geographical areas by arranging them into broadly similar chronological periods. The absolute chronology could then be established by contacts between the areas of the Aegean and other lands, particularly Egypt, where written records established fixed points in absolute dates.

The system has stood the test of time and is still, as we have seen, the basis of the way in which we view the Bronze Age in the Aegean. It does, however, have some weaknesses. Perhaps most notable is the fact that not only do the main divisions not necessarily coincide in the three major geographical areas, but even within each area change might occur at a different rate in different places. When the same terminology is used for both styles (of pottery, usually) and periods, illogicalities arise. For example, Middle Helladic and Middle Minoan pottery were being produced on the mainland and in Crete while pottery that is still described as Early Cycladic continued to be made in the islands.

In an attempt to avoid some of these difficulties, an alternative system has been applied to the Early Cycladic period in which the material is arranged into cultural groups. ('Cultures' in this system are defined, as above, as a 'consistently recurring assemblage of artefacts': in other words, the types of pottery, bronzes and marble objects which are regularly found together with certain types of

architecture and tomb construction constitute a culture.) Three cultures have been identified and, within these, smaller 'groups' of material can also be recognised. The rather daunting names given to these cultures are derived from sites or islands where typical material has been found.

The Grotta-Pelos culture, the earliest of the three, lasted from about 3200 to 2700BC. It includes material of the Lakkoudhes, Pelos and Plastiras groups; the transitional Kampos group overlaps between this and the succeeding Keros-Syros culture. The Grotta-Pelos culture sees the beginnings of most of the features that typify the Early Cycladic age as a whole, with the island population flourishing. It is, however, a time of relative isolation, with little evidence for foreign contacts.

The Keros-Syros culture is dated from about 2800/2700 to 2300/2200BC. It includes the large Syros group, to which belong many of the finest and most characteristic Cycladic products, particularly in marble. Contacts with the outside world intensify in this phase, and Cycladic influence is at its height.

The Kastri and Amorgos groups come towards the end of the Keros-Syros phase, and indeed of the Early Bronze Age as a whole. The Kastri group, named after the fortified site on Syros, includes pottery and bronzes of types which link it with the north Aegean islands and the western coast of modern Turkey, particularly the area around Troy. It has been suggested that the inhabitants of Kastri, and of other contemporary fortified sites, were foreign intruders from this region who gained a precarious foothold in the islands before being ousted by the native population. This view is disputed, however, and it may simply be that contacts with the north Aegean and the area around Troy were intensified at this time.

Whatever the reasons, it is generally agreed that the end of the Early Bronze Age was a period of change and decline in the Cyclades. There seems to have been depopulation and renewed isolation, with minimal external contacts. The long tradition of marble working also comes to a more or less complete end.

There is a sense of 'regrouping' with the Phylakopi I culture (and Phylakopi I group), which can be dated from about 2200 to 1800BC, largely contemporary with the Middle Bronze Age on the Greek mainland and in Crete. Larger, truly 'urban' settlements appear and the stage is set for the developments of the Middle and Late Bronze Age.

Although each culture has been given approximate dates, they are not the same as chronological divisions, and different cultures may well have existed simultaneously on different islands. The chronological chart on page 72 gives this information in tabular form and shows how the different systems relate to each other.

The exhibition of Cycladic objects in the British Museum is based on the cultural groups, along with approximate absolute dates, and the same system is used in this book. It should be remembered, though, that any system can only be approximate, the result of modern attempts to impose order on a more or less chaotic situation. Many problems remain unsolved, and further research may well materially alter the current picture.

4 Beginnings: the Grotta-Pelos culture

If the race was not far advanced in the arts of civilisation, it must at all events have had great numerical force . . .

JAMES THEODORE BENT

Paradoxically, evidence from the Greek mainland gives the earliest indication of human activity in the Cycladic islands. Obsidian from the island of Melos has been found amongst other material from early occupation in the Franchthi Cave in the Argolid, and must have been taken there at least before 8000BC and perhaps considerably earlier. This shows that Melos was certainly visited at this early time, though it may not have been permanently inhabited. While hunter-gatherers would find existence on small islands difficult because of limited resources, the introduction of farming at the beginning of the Neolithic period (about 6000BC) opened up new possibilities. The first evidence of permanent habitation in the islands, though, seems to be considerably later even than this, dating from the fifth millennium BC. This is late compared with the permanent occupation of neighbouring mainland areas, and perhaps reflects the difficulties even for settled farmers of living successfully on small islands with limited fertile land.

Evidence for the Neolithic occupation of the islands is sparse, and all accounts lean heavily on information from two thoroughly excavated sites – Saliagos, an islet off the coast of Antiparos, and Kephala on Keos. However, intensive surveys carried out on the islands of Melos and Keos have also added valuable facts, enabling a fuller and more balanced picture to emerge.

Excavations at Saliagos, now an islet but formerly at the end of a promontory extending from the single land mass formed by Paros and Antiparos together, have revealed the earliest excavated settlement in the Cyclades. It is dated by the excavators to about 5000 to 4500BC, and consists of a cluster of small dry-stone-walled houses. The finds included two marble figurines, one an abstract example rather like the later 'violin' type (pp.23–6), the other a 'fat lady' – a seated figurine with crossed legs and exaggeratedly rounded pro-

portions, of a type found elsewhere in the islands as well as on the Greek mainland and in Crete.

Surface finds have been made of material of the same type as that known from Saliagos, but no other comparable sites have been excavated nor does Saliagos have any obvious successors. Perhaps habitation of the islands died out for a while, again showing that life was not easily established there. It was not until the fourth millennium (about 4000BC or a little later) that the other excavated Neolithic site, that of Kephala on the island of Keos, began to flourish.

At Kephala both the settlement and the cemetery have been excavated. Here, too, the buildings, usually one-roomed rectangular houses, were of stone. Both single and multiple burials were found in the cemetery, with a limited number of grave offerings. The settlement was small, perhaps inhabited by no more than forty-five to eighty people.

While apparently unrelated to Saliagos, sites similar to Kephala are known on the Greek mainland, particularly in Attica. Some aspects of the Kephala way of life, especially the burial customs, as well as elements of the material have clear affinities with developments in the succeeding Early Cycladic period, though the direct evolution of one from the other has not been demonstrated. While no marble figurines came from Kephala, examples in terracotta may be forerunners of the figurines of the Early Bronze Age. Certainly the two well-preserved marble vessels found there, a pointed beaker and a flat-based bowl, look forward to later examples. The earliest evidence for the working of copper in the Cyclades comes from the site, though this was on an extremely small scale.

A large figure of grey limestone, thought to be Late Neolithic, was brought to the British Museum by Bent from the island of Karpathos, which lies to the south-east of the Cycladic

19

8

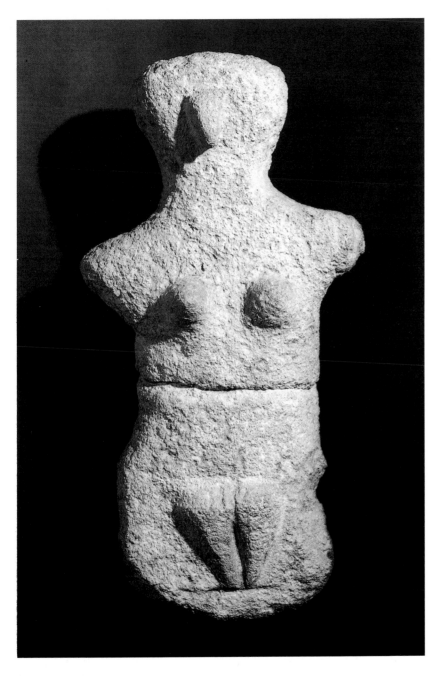

8 Limestone figure, probably of Late Neolithic date (about 4500–3200 BC), from Karpathos. (*BM Cat. Sculpture* A11)

archipelago. The piece has some features in common with Cycladic figurines, notably the beaked nose, pointed breasts and pronounced pubic triangle. It may in some sense be a predecessor of the Cycladic figures, though it is unusual and has no close parallels.

In general, the picture is one of sparse and discontinuous Neolithic habitation of the islands, and though survey work has brought further sites of the period to light, many are small and may not have seen permanent occupation. The contrast with the succeeding Early Bronze Age, when the population seems to have exploded and more than ninety per cent of the islands show evidence of occupation, could not be more marked.

The Early Cycladic age, which saw such remarkable developments, began about 3200 BC, and its first phase is known as the Grotta-Pelos culture. Quite why life in the Cyclades should suddenly have become so successful is not clear. Communications, indeed some sense of community, probably had a part to play: the increasing population was widely spread over the islands in settlements that are generally too small to have been completely self-supporting, and must have relied on some sort of mutual co-operation. This may have worked on an extended family or 'clan' basis, involving the obligation to help relatives in times of poor harvests or the like.

Lasting until about 2700 BC, the Grotta-Pelos phase has many of the features of an 'archaic' stage of development, when a range of objects began to be made which were to be typical of the Early Cycladic culture as a whole. These included vessels in both pottery and marble, and marble figurines. The latter, in particular, are at what might be termed an experimental stage, and some examples look very strange compared with the more assured and firmly established figurine types that were to come.

Grotta-Pelos settlements are not generally

15

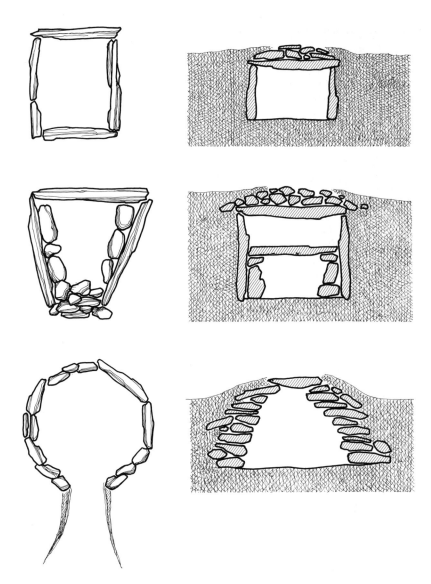

9 Plans (*left*) and sections (*right*) of Early Cycladic tomb types: (*top*) cist grave of the Grotta-Pelos culture; (*middle*) two-storeyed grave of the Keros-Syros culture; (*bottom*) corbelled grave of the Keros-Syros culture, of the type found on Syros.

well preserved but almost all have cemeteries nearby, and it is the size of these, often with only ten to fifteen graves in each, that gives some indication of the settlement size. Most can only have been farmsteads or small hamlets. Remains of the buildings are almost non-existent, suggesting extensive use of perishable materials in their construction. The somewhat later stone vessels known as hut pyxides – boxes made in the shape of huts – perhaps give some idea of what wooden or mud-brick huts may have looked like. It seems strange, though, that stone, a plentiful material that had been extensively used in the Neolithic period and was still used for the construction of graves, should be ignored for building houses. One might expect stone foundations, even if the upper parts were of wood. Moreover, some stone-built structures of this period have recently been uncovered at Grotta on Naxos. Perhaps, then, the architectural remains of this culture in general were simply too slight, and have become too jumbled, to be recognised – dry-stone walling, after all, can become just a scatter of stones after four and a half thousand years. Certainly at the end of this phase, when pottery of the Kampos group is in use, individual houses built of stone have been found near to certain cemeteries. These houses are usually rectilinear, with one or two rooms and walls made of stones embedded in clay.

The construction of Grotta-Pelos graves is much better known, and indeed throughout the Early Cycladic period graves were of a type that provided excellent conditions for preservation both of the graves themselves and of their contents. As a result, the vast majority of known Early Cycladic material comes from graves, and we are therefore more familiar with the land of the dead than that of the living. Known as cist graves, the Grotta-Pelos examples consist of rectangular or trapezoidal cuttings in the earth, fairly shallow (usually

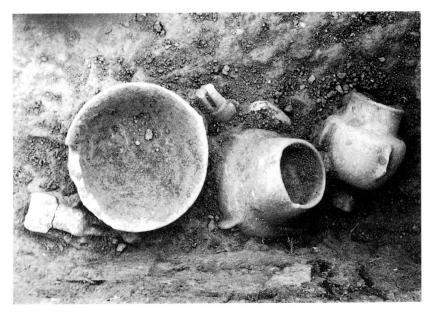

10 Finds emerging during the excavation of a Grotta-Pelos cist grave in the Plastiras cemetery, Naxos.

Most graves of this phase contained only a single body, but the graves were clustered into groups within the cemetery, perhaps indicating family relationships between the dead. Before the end of the period some multiple graves are found, and in the Keros-Syros culture multiple or 'family' graves seem to take over from 'family' clusters.

The goods put into the graves in the Grotta- Pelos period vary in quality and number. Some graves contained nothing, while others had only one or two pottery vases. Pottery was by far the most common offering; marble objects were rare and metals almost never found, though blades of obsidian were quite common. Simple beads and ornaments of stone or shell might also be included. The richest graves contained not only the greatest variety of types of offering, but sometimes large quantities of a single type. For example, as many as fourteen marble schematic figurines have been found together in a single grave, while Grave 'D' at Kapros on Amorgos, from which a figurine in the British Museum's collection is said to have come, also contained as many as five further figurines, a silver bowl, three necklaces, a bronze needle, two stone handles, a cylinder seal of north Syrian type and a fragment of bone.

Already, then, differences in the wealth of graves are very apparent, and this may be significant in terms of the stage of development reached by Cycladic society, where some notion of rank or of social distinction has obviously emerged.

The distinctive material typical of the Grotta-Pelos phase is well represented in the Museum. The culture is named after sites on Naxos and Melos respectively, and finds have been particularly common on the islands of Naxos, Paros and Antiparos. As we have seen, much material from Antiparos came to the Museum from Bent's excavations. Pottery is perhaps the most basic element in the defini-

between 0.3m and 0.4m deep) and with, at this stage, all four sides lined with stone slabs. The floors were occasionally paved. The graves were usually very small, often less than a metre long, meaning that the body had to be interred with the knees drawn up towards the chin and may even have been tied to make it small enough (cremation was never practised in the Early Cycladic period). The stone slab at one narrow end of the grave was the last to be placed, sometimes with its top edge protruding above the surface of the ground. The grave was then closed, either with two or three stone slabs or with a single large undressed stone. A layer of earth was laid on top of this, some-times with smaller stones or pebbles on it, perhaps to act as a grave-marker. Sometimes the stones on top of a grave were built up to form a platform above it. In some instances, the spaces between graves were also built up with stones so that the platform was continuous, while separate platforms at some distance from the graves were also known.

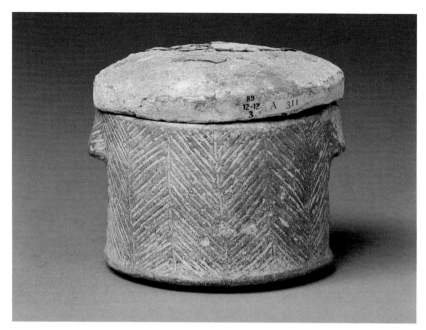

11 (*Above*) Pottery cylindrical pyxis (box) with rounded lid and incised herringbone decoration. Grotta-Pelos culture, about 3200–2800BC. Found on Antiparos. (*BM Cat. Vases* A311)

12 (*Below*) Pottery spherical pyxis with two lugs and string holes in the lid for attachment. Grotta-Pelos culture, found on Antiparos. (*BM Cat. Vases* A316)

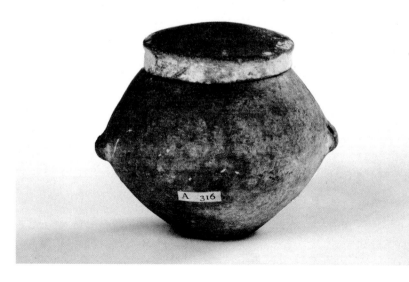

tion of the phase and is therefore a good place to start.

Pottery of the Grotta-Pelos phase was made by hand (the potter's wheel was hardly known in the Early Cycladic period as a whole) and was generally of a black or reddish colour, though a pale buff fabric is also found. Variations in colour arise not only from the use of different clays, but also from incomplete control over the firing process. The pottery was frequently rubbed or burnished before firing to give a smoother, slightly shiny appearance and a more impervious surface. Nonetheless, the pottery of this time is often rather clumsy in appearance, the vessels thick-walled and the clay crumbly with imperfections.

The most common shapes are cylindrical boxes (pyxides) with slightly rounded lids, 11 spherical pyxides and collared jars. The shape 12 of the bodies of these jars resembles the shell of a sea-urchin and seems to have appealed 13 particularly to Cycladic taste, as it is found also in contemporary marble vessels. The collared jar was also occasionally fitted with a foot. 14

Vertically pierced lugs are characteristic of the phase. On the pyxides these are often in positions corresponding to holes pierced through the lids, and presumably allowed the lids to be tied on with string. The lugs on the jars may have been purely decorative, though they might have been used as string holes if the jars were suspended in some way.

Incised rectilinear decoration was common on all the Grotta-Pelos phase pottery shapes. Herringbone pattern was particularly popular, and the incisions were sometimes filled with a white chalky substance to make them more noticeable.

Pottery of the Kampos group, in chronological terms transitional between the Grotta-Pelos and the succeeding Keros-Syros phase, has features in common with both. A particular type of narrow-necked flask or 'bottle' is 16 characteristic of this group. Along with incised

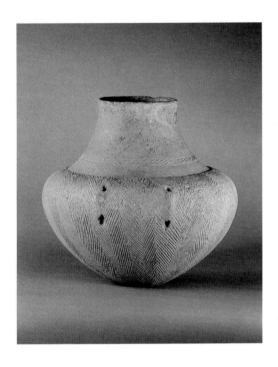

13 Pottery collared jar with sea-urchin-shaped body and incised herringbone decoration. Grotta-Pelos culture, about 3200–2800BC. Found on Antiparos. (*BM Cat. Vases* A301)

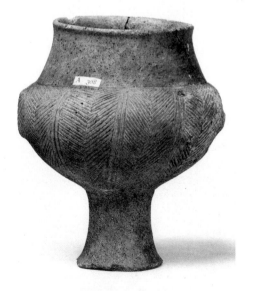

14 Pottery collared jar with foot and two pairs of lug handles; sea-urchin-shaped body with incised herringbone decoration. Grotta-Pelos culture, about 3200–2800BC. Found on Antiparos. (*BM Cat. Vases* A308)

curvilinear designs, stamped decoration is now introduced, in which the pattern is achieved by pressing a certain shape repeatedly into the clay while it is wet.

The so-called 'frying pans' of the Kampos group, shallow flat vessels with squared handles, often bear the most elaborate versions of stamped decoration on their undersides. The type continues, in slightly different form, into the Keros-Syros culture and constitutes one of the best known as well as most enigmatic products of the Cycladic potter (pp. 35–6).

Early Cycladic figures as a whole divide into two types, schematic and naturalistic. Schematic figures are relatively common and particularly various in the Grotta-Pelos phase, though they continued to be made throughout the period as a whole. The earliest examples have characteristics in common with contemporary figurines produced elsewhere in the eastern Mediterranean area, though they develop in a distinctively Cycladic way.

Schematic figures are generally very flat in profile and characterised by the lack of a clearly defined head. The simplest forms have scarcely ceased to be beach pebbles – Bent remarks that during his excavations he found 'some flat, round bits of marble which I threw away as mere pebbles at the time', but which he later decided were probably 'rude representations of the human form'. In fact, Bent was rather ahead of his time in his recognition of schematic figures as based on human forms; indeed, he even suggested that two schematic figurines he found together in the same grave might represent man and wife. These two are typical in their flat profiles and prong-like 'heads'. The notched waist of one brings it close to the 'violin' type, and it certainly has a more female look than its straight-sided companion.

'Violin' figurines are so called because of their shape. They sometimes bear incised

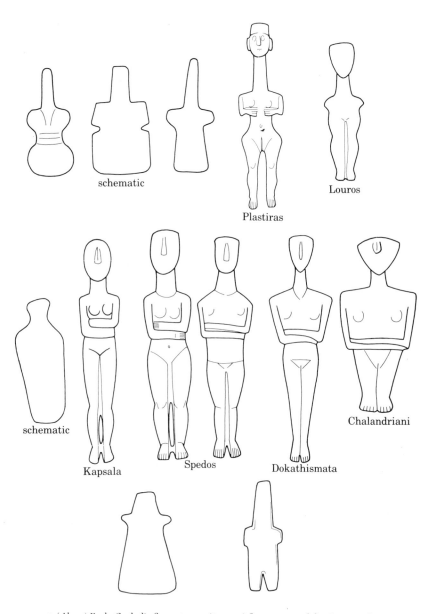

schematic

Plastiras

Louros

schematic

Kapsala

Spedos

Dokathismata

Chalandriani

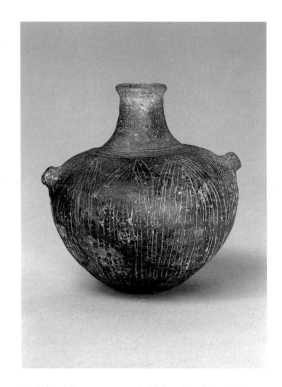

16 (*Above*) Kampos group 'bottle' with a shiny black surface and incised decoration, dating from about 2800–2700BC. Found on Antiparos. (*BM Cat. Vases* A309)

15 (*Above*) Early Cycladic figure types: (*top row*) figure types of the Grotta-Pelos culture; (*middle row*) figure types of the Keros-Syros culture; (*bottom row*) figure types of the Phylakopi I culture.

17 (*Right*) Fragment of a vessel usually described as a pyxis lid, but close in shape to a 'frying pan'. The radiating pattern is achieved by a simple version of stamped decoration. Dating from about 2800–2700BC, it was found on Antiparos. (*BM Cat. Vases* A315)

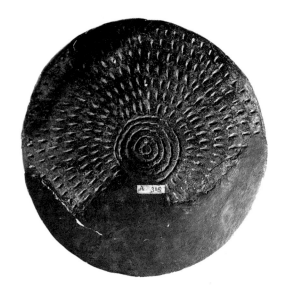

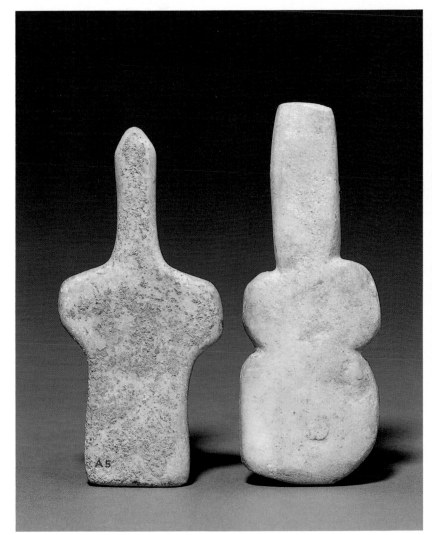

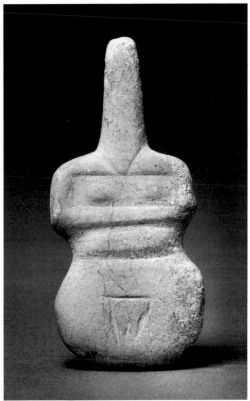

19 (*Above*) 'Violin' figurine with unusual indications of the arms and breasts, as well as an incised pubic triangle and deep waist groove. Grotta-Pelos culture, perhaps a rather late example, about 2800BC. Found on Amorgos. (*BM Cat. Sculpture* A7)

18 (*Above*) Two schematic figurines found in the same grave on Antiparos, and described by Bent as perhaps a male and female pair. Grotta-Pelos culture, about 3200–2800BC. (*BM Cat. Sculpture* A5 and A6)

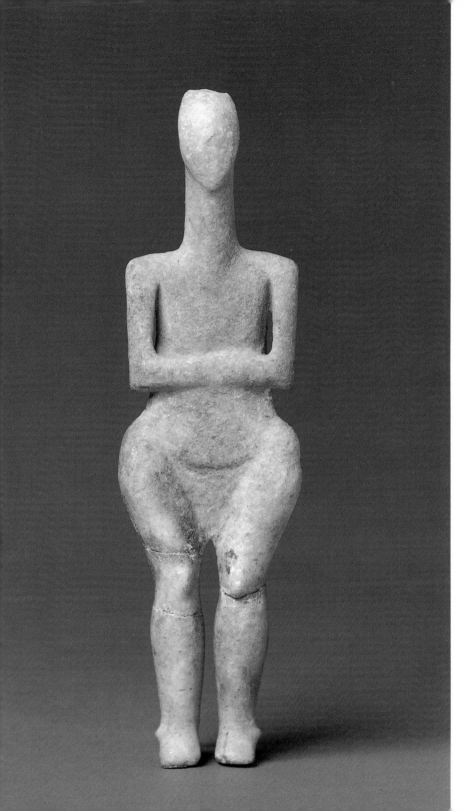

surface detail, particularly pubic triangles and grooves at the waist (perhaps similar to those occasionally found on later 'folded-arm' figures). One violin figurine is unusual because it has breasts and an indication of arms, as well as the incised pubic triangle and a deep groove at the waist. It may be rather a late example, perhaps contemporary with naturalistic figure types, by which it seems to have been influenced.

The first of the naturalistic varieties of figurine is known as the Plastiras type (named after the cemetery on Paros where examples were found). The figurines are small, normally less than 30 cm high, and are made in a standing position with their hands (or fingertips) meeting above the waist. They are fairly flat in profile but have strange proportions, often with remarkably long necks, angular upper bodies and bulging thighs.

The legs of Plastiras figurines are usually separated for their whole length – technically difficult to do – and holes bored by the sculptor to rejoin broken sections of leg are quite frequently found (such mends are also sometimes seen on schematic figures). While female figurines predominate, the Plastiras variety also includes a high proportion of male examples. Both females and males often have carefully delineated facial features: very occasionally inlaid pebbles were used for the eyes, and sometimes such figurines wear a sort of cap or a plain, rather fez-shaped hat.

After the occasionally rather grotesque elaboration of the Plastiras type, the following Louros variety seems very austere. Again the figures are small (usually not more than about 20 cm tall) and fairly flat in profile. They have

20 Figurine of Plastiras type (about 3000–2800BC), said to be from Grave 'D' of the Kapros cemetery on Amorgos. This figurine exhibits the long neck, angular upper body and bulging thighs characteristic of the type, though the cut-out areas separating the upper arms from the body are very unusual. (*BM Cat. Sculpture* A27)

no facial features, no arms – the shoulders simply extend to triangular projections – and their legs usually taper away to points or very rudimentary truncated feet. They are almost like ghosts of Cycladic figurines, as if all vitality has temporarily seeped away from the tradition. They occur, in fact, at a time of transition between the vigorous (if not to our eyes always successful) products of the Plastiras tradition and the more restrained and assured forms of the Keros-Syros culture. They look forward rather than backwards: the simplification of forms that they represent will become an essential part of the tradition of figure production.

Sculptors in marble also began to produce impressive marble vessels in the Grotta-Pelos phase. Again, most examples known to us come from graves. There is no reason to assume that all were made exclusively for funerary use, but like the figurines they were probably very special products, not merely for domestic purposes.

The most common Grotta-Pelos type, of which hundreds of examples have survived, is known as the 'kandila'. These vessels have a sea-urchin-shaped body, a conical foot and a conical neck, with four vertical lugs that are horizontally pierced. The modern Greek name *kandila* (plural *kandiles*) means lamp and refers particularly to the sanctuary lamps in churches which the Early Cycladic examples somewhat resemble; indeed, they have sometimes been used as such. There is no trace of fire-blackening on the ancient kandiles, however, so it is very unlikely that they were originally used as lamps.

Kandiles range considerably in size, from about 7 to 37 cm in height. Many examples

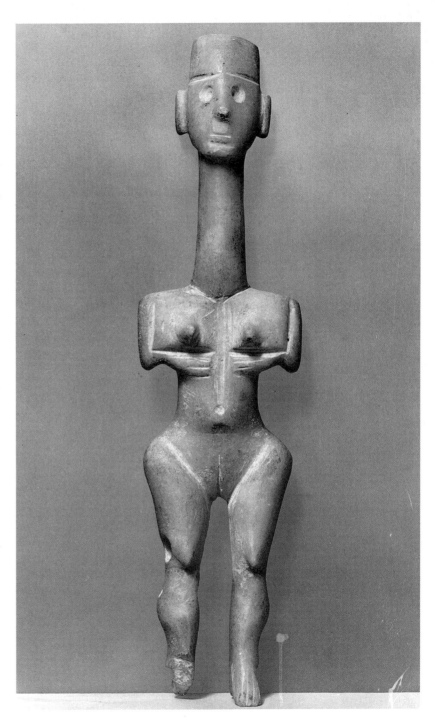

21 Figure of Plastiras type (about 3000–2800 BC) wearing a *polos* or pill-box hat. The neck is exaggeratedly long, and the eyes are indicated by drill holes. (Metropolitan Museum of Art, New York, 45.11.18)

are quite large and certainly very heavy. Their weight often arises from the fact that they are not hollowed out as much as they could be, and in fact their internal space is often surprisingly small. The effort required to make these vases, by hand and without metal tools, must have been very considerable. The hollowing of the interior was perhaps particularly time-consuming and must have involved boring a number of holes with a wooden circular drill, perhaps tipped with an obsidian blade and helped by abrasive emery powder. In this way a central core could be released and painstakingly removed, and the interior of the vessel subsequently smoothed. In view of the laborious processes involved, it is perhaps not surprising that the craftsmen chose to leave the vessels thick-walled, which also reduces the risk of damage. More surprising is the achievement of such balanced, symmetrical and pleasing shapes in these kandiles – an example, like so much of the work of Cycladic sculptors, of the art that conceals art, or certainly conceals effort.

A shape related to that of the kandila is a jar of more spherical form with a small neck and foot, again with four suspension lugs. One of the two examples of this shape in the British 24 Museum contains seashells. Bent refers to finding seashells in one of the stone vessels from his excavations, and though he gives the impression that he is referring to a kandila proper, it is more likely that the shells have always been kept in the jar in which they were found and originally placed as offerings in the grave.

23 Tall beakers with two vertical lugs are equally typical of the Grotta-Pelos phase. As mentioned (p.18), a Neolithic antecedent with a pointed base came from Kephala, though Grotta-Pelos examples are designed to stand. Again, the range of sizes is considerable, from about 7 to 27 cm high. Hemispherical bowls, often with single lugs, and rectangular pal-

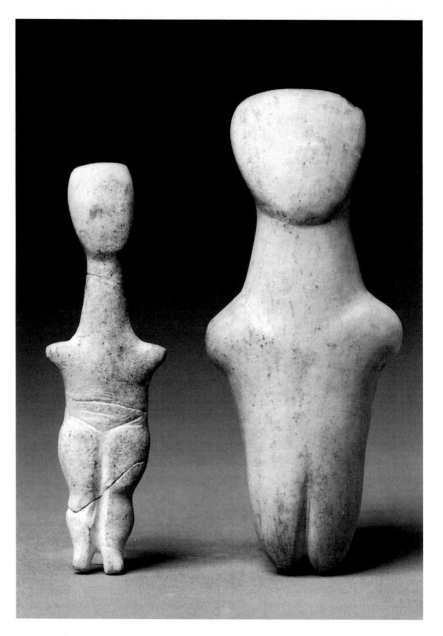

22 Two figurines of Louros type (about 2800–2700BC), found (*left*) on Antiparos and (*right*) on Paros respectively. Both are typically simple and featureless, though the figurine on the right is an unusually thick, solid example. (*BM Cat. Sculpture* A8 and A10)

ettes are also quite common in Grotta-Pelos graves but are not represented in the Museum. Both these types often contain remains of pigment, which may have been used in some way in the funeral rites.

Metal finds of the Grotta-Pelos culture are rare and, although there is evidence for some very small-scale Neolithic copper-working at Kephala, it is clear that the initial phase of the Early Bronze Age is not aptly named: it is not in fact a truly metal-using culture. Some odd bits of copper wire have come to light in Grotta-Pelos tombs, a necklace of more than two hundred silver disc-shaped beads was found on Naxos, and a single gold bead, the only example of gold in an Early Cycladic context, came from the same island. In general, though, tools of bone, wood and stone must have been used for all purposes. Obsidian was therefore a very useful resource, with many applications for the islanders as well as being extensively traded abroad. It occurs frequently in Grotta-Pelos tomb groups.

While the necklace of silver beads from Naxos was a unique find, beads of stone are quite common and are often animal-shaped. Some stone vases in the shapes of animals are also known.

The Grotta-Pelos culture did not come to an abrupt end. Instead, development was continuous on many of the islands from the firm foundations laid in this phase, through the transitional Kampos group, to the richer and more varied Keros-Syros culture which followed.

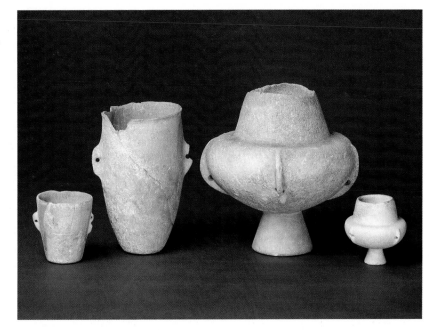

23 (*Above*) Marble vases of the Grotta-Pelos culture (about 3200–2800BC), showing the range of sizes of the 'kandila' and beaker types. They are all from Antiparos except the second from left, which is of unknown provenance. (GR 1890.1–10.5, 1843.5–7.76, 1889.12–12.1 and 1890.1–10.8)

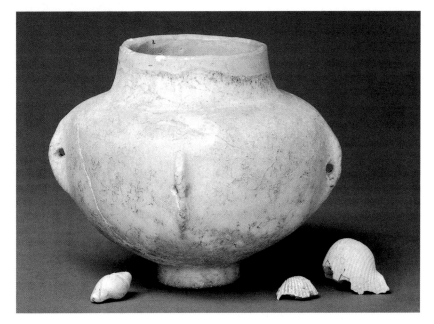

24 (*Right*) Marble jar of the Grotta-Pelos culture (about 3200–2800BC), found by Bent on Antiparos with seashells inside it. (GR 1884.12–13.1)

5 A golden age: the Keros-Syros culture

I love and admire Cycladic sculpture. It has such great, elemental simplicity.

HENRY MOORE

The Keros-Syros phase (about 2800/2700–2300/2200BC) saw the full flowering of the Early Cycladic culture. Settlements were larger, more carefully planned and better built, metallurgy began to be practised on a truly wide scale, potters increased their repertoire and sculptors produced a remarkable range of figures and stone vases. The products of Cycladic craftsmanship were both exported abroad and widely copied. Although settlements of this period are better known than their predecessors, the rich surviving material owes its existence mainly to the fact that the objects were placed in tombs. The graves of the Keros-Syros dead have revealed the finest products of what can rightly be called the islands' golden age.

Keros-Syros settlements were usually situated near the sea, which was clearly of the greatest importance for the islanders both as a source of food and as the major means of communication. The accessibility of fertile land, fresh water and building materials no doubt also played a part in the choice of site. Some were located on hilltops, and in these cases defensibility was clearly paramount. The steep slopes leading to Kastri, near Chalandriani on Syros, to Panormos on Naxos or to Mount Kynthos on Delos may have had a deterrent effect that was reinforced by the presence of large-scale fortification walls either encircling the stronghold or at least protecting the approachable sides. Elsewhere, as at Ayia Irini on Keos and Grotta on Naxos, building on a promontory provided a naturally defensible position, where only a relatively narrow neck of land was vulnerable.

Although the settlements were larger than their Grotta-Pelos predecessors, they were still only comparable in size to a modern village. The cemeteries were certainly larger, ranging from about fifty to several hundred graves, but this may partly be due to more settled conditions resulting in cemeteries being used over

longer periods. The fortified hilltop sites may have protected their surrounding areas, since in some cases there is evidence of settlement, or at least scattered houses, outside the walls. At Kastri, traces of buildings have been found some distance from the fortified hilltop, near the very extensive cemetery; this may have been the site of the main Keros-Syros settlement, the stronghold only being occupied at a late stage of the Keros-Syros phase, at the time of the Kastri group. On Mount Kynthos, only the area inside the walls is known, though the site does seem to have been inhabited from earlier Keros-Syros times as well as in the Kastri group period. Panormos on Naxos is a small fortified site with some traces of scattered buildings in the vicinity. It is possible, though not certain, that here, too, there was occupation before the time of the Kastri group.

There seems little reason to doubt that the fortified hilltop sites saw permanent occupation, though they may well also have had a special protective function in times of need. While Kastri itself has revealed evidence only for a single late stage of occupation, fortifications elsewhere (including Mount Kynthos and perhaps also Grotta) may be earlier, so fortified sites could have been typical throughout the Keros-Syros culture.

The fortifications of Kastri are the best known, and they are impressive. A solid wall with six rounded bastions was built across the only accessible side of the hilltop. Concealed entrances were well protected by these fortifications, and an outer wall completed the defence system. The area thus protected was only about 50 metres across. At Panormos, a wall with similar but rather more irregular semicircular bastions encircled a site about 25 metres wide. There were less well defined traces of fortifications on Mount Kynthos, where the site was probably relatively large but is very poorly preserved.

The houses behind the fortification walls

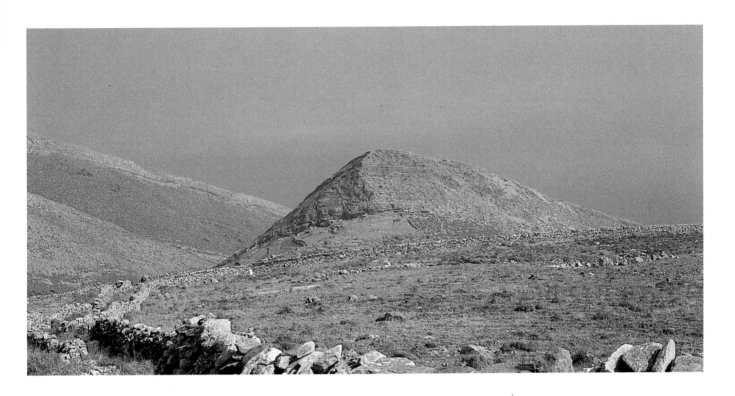

25 The hilltop position of Kastri, at Chalandriani on the island of Syros.

were usually densely packed in a very irregular arrangement and separated by narrow passageways. They were small, consisting of only one or two rooms, and though some were rectilinear in plan others had curving walls, perhaps so that every last bit of space, however oddly shaped, could be used. For the same reason, houses sometimes had walls formed by part of the natural rock on which they were built. Others had walls in common, or in some cases the fortification wall itself formed a wall of the house. The plans of such settlements are therefore often difficult to understand, as it is not clear where one house ends and another begins. It seems likely, though, that the inhabitants were as densely packed as the small rooms that they inhabited.

The houses were built of either slab-like or rough stones embedded in clay or, as at Kastri, with dry-stone walling, and the walls were plastered on the inside with a mixture of clay and broken straw. The floors were sometimes paved with flat stones or otherwise were simply of beaten earth, and the roofs were light constructions, probably of branches or reeds laid on wooden beams and perhaps covered with earth or clay. Fixed hearths were not usually a feature of the houses, which must mainly have been heated by portable braziers, though fixed terracotta hearths have been found at Ayia Irini on Keos.

Ayia Irini, and Phylakopi on Melos, are two thoroughly excavated settlements with a long history in the Bronze Age. Early Cycladic remains at the latter, in particular, tend to be obscured by later buildings, but the sites are of major importance for the stratigraphic (and therefore chronological) evidence that they supply. Little can be said about the Early Cycladic layout of Phylakopi, but it seems that

at Ayia Irini, which is situated on a promontory and therefore occupies a less restricted space than the hilltop sites, buildings were larger, neatly built with dry-stone walling of local schist, and altogether more spaciously arranged than the crowded citadels of the islands further south.

Recent excavations have shown that Grotta, on Naxos, was important in the Early Cycladic period, and remains dating from the Neolithic, Grotta-Pelos and Keros-Syros phases have been uncovered. Some of the Early Cycladic settlement is now under the sea, however, and modern buildings overlie other parts, so its extent and layout may never be thoroughly known. The same is true of the settlement that lies under the modern town of Paroikia on Paros.

Cemeteries

28 While some Grotta-Pelos cemeteries continued to be used with little apparent change in burial customs during the Keros-Syros period,
9 in general a greater range of grave types was introduced. Multiple burials, sometimes in tombs of more than one storey, became prevalent; graves were more commonly paved with stone slabs, and pillow slabs were included to support the head of the deceased. Grave goods were different, of course, including a range of objects typical of the new era.

The rectangular or trapezoidal stone-lined cist grave continued to be the most common type, though it differed from Grotta-Pelos cists (pp.20–21) in that one side was closed with dry-stone walling, rather than with a fourth upright slab. This formed an entrance to the grave and made it easier to use the tomb for successive burials. Multi-storeyed tombs probably also arose out of the custom of multiple burial: the lower part of the tomb could be used as an ossuary to store old bones while the most recent interment was placed in the upper part. In spite of the relative elaboration of the tombs,

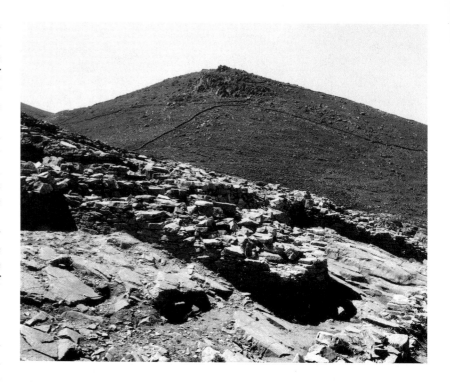

the dimensions were still small and bodies continued to be put into them in a contracted position. Usually the corpse was laid on its right side, the knees drawn up to the chest.

The very extensive cemetery of Chalandriani on Syros belongs to the Keros-Syros culture but has some features not found elsewhere, including the construction of the tombs. These varied in plan and were 'corbelled', or built up with overhanging courses of dry-stone masonry, until the space at the top could be closed with a single slab. Most of the tombs contained only a single burial and the tombs were arranged in clusters – a habit that had largely died out elsewhere in this phase. In fact, the Chalandriani cemetery lay in two distinct areas. In its western part Tsountas excavated fifty graves (about a hundred others had previously been opened), while in the eastern part 490 tombs were

26 The stone-built fortifications of Kastri.

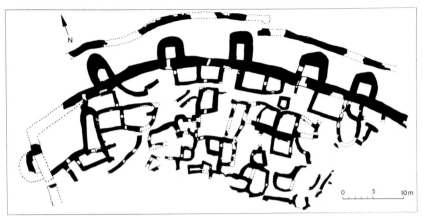

27 (*Above*) Plan of the fortifications of Kastri, showing the massive defence wall and horseshoe-shaped bastions, the outer defences, and the tightly packed irregular structures within the settlement.

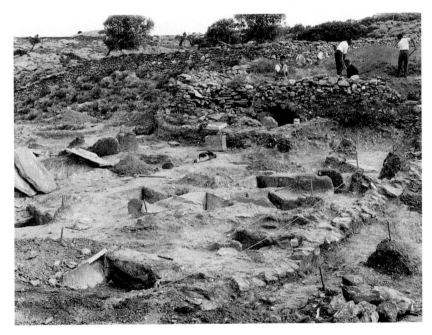

28 (*Above*) The excavation of the Agioi Anargyroi cemetery, Naxos, which was in use from later Grotta-Pelos to Keros-Syros times.

grouped in four clusters. This very large cemetery presumably served the hilltop site of Kastri, across a deep ravine and about a kilometre away to the north, as well as the nearby settled area of which only scattered traces are known.

While early excavators tended to pay insufficient attention to the details of the burials they found, more recent work has too often been in the wake of the depredations of tomb robbers. As a result, information about the age or sex of the individuals buried in Cycladic graves, and how these factors relate to the offerings left with them, is almost entirely lacking. It is clear, though, that the number and type of goods placed in the graves varies enormously. Some graves have no goods whatever, others perhaps only a pot or two. Marble figurines are found in only a small proportion of graves, though a number of them might accompany a single burial. Other grave offerings included marble vessels, jewellery of silver or bronze, tweezers and toilet articles, stone or shell beads, bone tubes containing colouring matter, and so on. With the Amorgos group, towards the end of the Early Bronze Age, weapons, particularly daggers and spearheads, began to be included in graves.

The discovery of built platforms in the cemeteries of both this and the previous phase, sometimes lying over the graves or sometimes at a distance from them, seems to indicate some fairly large-scale activity in the cemetery. The platforms may have been the site of funerary rituals: their scale and careful construction perhaps indicate that these were on a communal basis.

Pottery

The abundant pottery of the Keros-Syros culture is important in the definition of this phase and the smaller groups that it encompasses, and so is a good place to begin our survey.

29 (*Above*) Shallow pottery bowl of the Keros-Syros culture, about 2700–2200BC. Found at Chalandriani, Syros. (*BM Cat. Vases* A327)

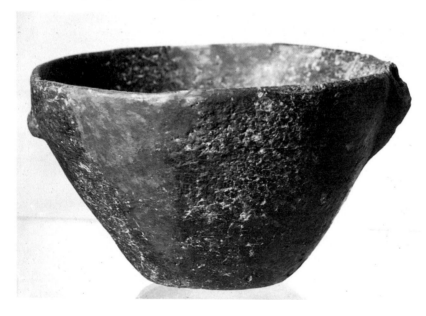

30 (*Above*) Pottery conical spouted bowl with a lug opposite the spout. Keros-Syros culture, about 2700–2200BC. Found on Antiparos. (*BM Cat. Vases* A320)

While many of the types derive from those of the preceding culture, Keros-Syros pottery includes a much more varied and exciting repertoire of shapes. Painted decoration appears for the first time, though incision continues to be used, while some pots are covered with shiny dark paint.

Amongst the most common shapes are plain shallow bowls and conical cups. The latter often have impressions of leaves or woven mats on their bases. These may have been picked up when the pots were left to dry before firing, though it is possible that mats were used to turn the pots during manufacture or indeed to carry them. Conscious ornament is also a possible interpretation: the leaf impressions in particular are both so symmetrical and so deep that they may not have arisen accidentally. Both these vessel types are eminently practical and are probably examples of the tableware of the time. The shallow rounded bowls have frequent counterparts in marble.

One rounded vessel with a very wide open spout is an early example of a type known as a 'sauceboat'. In their more developed form these usually have longer spouts, a handle on the side opposite the spout, and a ring foot. They therefore look very much like modern sauceboats, hence the name, though their original use is not clear. They may have been drinking vessels or possibly oil lamps, with the spout supporting the wick. However, signs of burning on the spout are rare. Spouted bowls of the Keros-Syros culture are found in both pottery and marble, and probably represent the form from which the 'sauceboat' developed. The shape may therefore have had an island origin. It is important because it is found far more frequently on the Greek mainland, in Early Helladic II contexts, and therefore shows the chronological connection between Early Helladic II and the Keros-Syros culture.

The jar with conical neck, so common in the

Grotta-Pelos phase, continues to be found, though it has changed somewhat so that the neck turns outwards at the top and the foot becomes a flaring pedestal. Incised decoration, often triangles or spirals, is frequently found on these jars.

The most elaborate incised decoration, though, can be seen on the 'frying pans' of this phase, which differ from their predecessors in the shape of the handle, now usually in the form of a double prong. Various suggestions have been made about the uses of these vessels: the possibility that they may have been specifically intended for offerings to a deity; that they were designed not to be filled but to be suspended with their decorated underside on view; that they had membranes stretched across them and were used as drums; or that they were filled with water and used as mirrors. One theory even suggests that they were navigational instruments. The puzzle remains, but it seems fairly certain that the vessels were in some sense special. They are

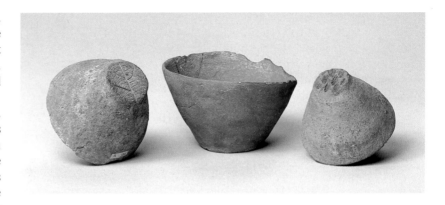

31 (*Above*) Three conical cups of the Keros-Syros culture, about 2700–2200BC, two of them inverted to show the impressions of a leaf and a mat on their bases. Found at Chalandriani on Syros. (*BM Cat. Vases* A322–324)

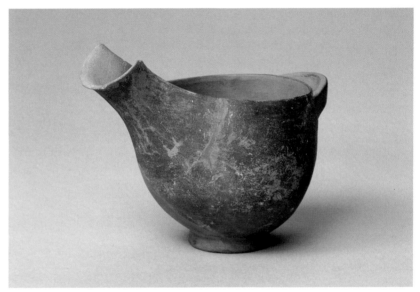

32 (*Above*) Pottery 'sauceboat' of the Keros-Syros culture, about 2700–2200BC. From Chalandriani, Syros. (*BM Cat. Vases* A263)

33 (*Left*) Drawing of a pottery 'frying pan' with incised running spirals, a representation of an oared ship with a fish emblem on the high prow, and a female pubic triangle above the two-pronged handle. Keros-Syros culture, about 2700–2200BC, found at Chalandriani on Syros. (National Museum, Athens, 4974)

made in chlorite schist and marble, as well as in pottery, and are often very elaborately and beautifully decorated. Frequently the iconography has to do with the sea: ships are depicted on at least ten 'frying pans', sometimes with fish emblems at the prow and often with running spirals that suggest waves. Some symbolic connection with the fruitfulness of the sea may be suspected here. Even more striking is the fact that the space above the prongs (or 'legs') of the handle sometimes bears a representation of female genitalia. This, along with the womb-like shape of the pans as a whole, may connect them with human fertility. Although many of the pans have unspecific, abstract decoration, there are enough examples with specific themes to allow us to suggest that this very special shape was connected with notions both of human and more general fertility in the minds of the islanders.

Painted vessels are one of the most interesting developments of this phase, though they are rare and are not represented in the British Museum's collections. They come mainly from the island of Syros, where a variety of shapes bore painted decoration, usually in dark, slightly shiny paint on a pale slipped background. The designs are almost always rectilinear, including triangles, lozenges, zigzags and chevrons.

The well-known vessel from the Chalandriani cemetery, Syros, shaped like an animal sitting with a bowl held in its forepaws, is an example of this painted ware. It is also an example of the inventiveness – perhaps, indeed, the sense of humour – of the Cycladic potter. However, as is so often the case in the highly traditional world of Early Cycladic art, what originally seemed the unique *jeu d'esprit* of an individual artist now proves to be part of a larger group of objects of the same type. A second fragmentary example, also of painted ware, comes from Ayia Irini, while two un-

34 (*Left*) Drawing of the pottery 'hedgehog' from Chalandriani, Syros. Keros-Syros culture, about 2700–2200BC. (National Museum, Athens, 6176)

35 (*Below*) Pottery animal, perhaps a pig, said to be from Melos. The animal originally held a bowl in its forepaws, which was connected by a hole to the hollow interior. Keros-Syros culture, about 2700–2200BC. (GR 1929.11–12.1)

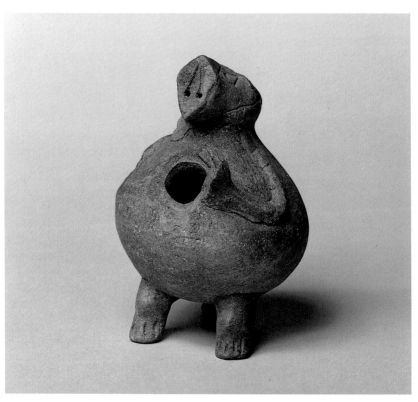

painted examples are now known, one from Panormos on Naxos and the other, in the British Museum, said to be from Melos. The latter is in a sadly fragmentary condition, but it is clear that in this case, too, the animal held in its forepaws a bowl (now missing) which was connected by a hole to the hollow interior. The animal 'sits' on a stump – perhaps a stool, perhaps a stylised tail – that balances the two stubby back legs to form a stable tripod base.

It is not clear what animal is intended (if indeed it is the same in all four cases). The eyes are lozenge-shaped on all but the Syros example, where they are more rounded. All have pronounced snouts, though these are more pointed on the two painted examples and that of the animal in the British Museum is flattened, again into a lozenge shape. The ears are often rather battered but in all cases seem to be small, upright and pricked slightly forward. The two painted examples seem most like hedgehogs, though the one from Syros has been described as a bear, while the two unpainted animals perhaps more closely resemble pigs.

Pottery belonging to the Kastri group, named after the site on Syros, is not represented in the Museum but is characterised by a dark lustrous painted surface. Some shapes have been introduced from Anatolia, including the two-handled 'depas' beaker. These are important chronologically, since they can be associated with a particular stage in the history of the city of Troy (specifically with Troy II and III), and are also of historical importance, since they have led to the suggestion of extensive Anatolian incursions into the Cyclades at this time. However, at Ayia Irini such foreign types represent only a small element in the pottery as a whole, and so the evidence from this important site does not support the idea of foreign invasion.

While pottery of the Kastri group is found mainly in the northern Cyclades towards the

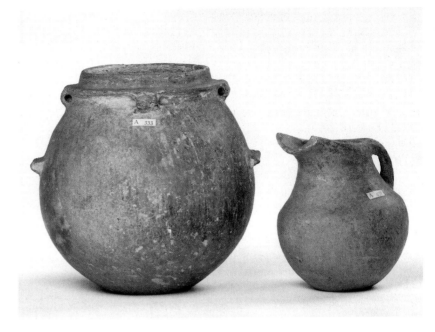

end of the Early Bronze Age, it seems that material of the Amorgos group was current in the eastern and central islands. The differences between the two were perhaps largely a matter of regional rather than chronological variation, though this is not yet entirely clear. Represented in the Museum by four vases, Amorgos group pottery has a rough buff-coloured surface and rather baggy shapes. Handles often bear incised criss-cross decoration.

In conclusion, then, Keros-Syros pottery shows increased control of the medium combined with new inventiveness to produce a greatly enriched repertoire. Mutual influences clearly passed between pottery and the stone vases (discussed in more detail below). While many vessels were made simply to fulfil practical functions, some seem to have special ritual or funerary purposes, and it is amongst these that the most elaborate pieces are to be found.

36 Jar and jug of the Amorgos group. From Antiparos, late Keros-Syros culture, about 2400–2200BC. (*BM Cat. Vases* A333 and A336)

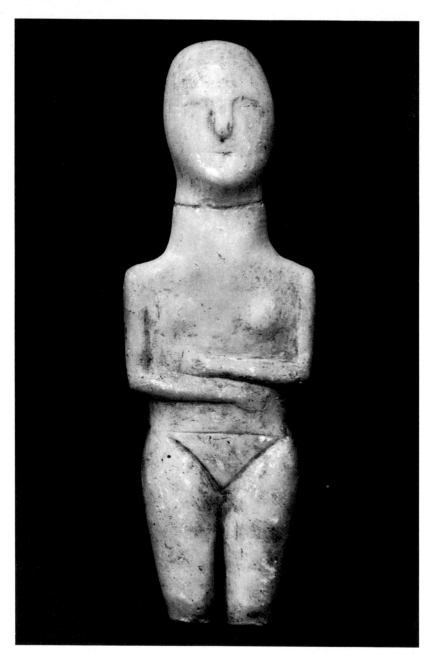

37 Pre-canonical marble figurine from Paros, transitional between the Grotta-Pelos and Keros-Syros cultures, about 2800–2600BC. (*BM Cat. Sculpture* A26)

Sculpture

The Keros-Syros phase sees the introduction of the figure with folded arms. It is sometimes 15 referred to as the 'canonical' type because it is the most frequently found, and for five centuries certain strict formal conventions were maintained, with only stylistic changes. Such figures are certainly the most famous products of the Early Cycladic world. The sculptors of the Keros-Syros phase have acquired a new assurance. The attitudes and proportions of the figures now become established in a tradition that will be followed for generations, and within this tradition certain types develop which can be recognised again and again, though with infinite subtle variations that distinguish individual works.

Simplicity is perhaps the hallmark of Cycladic sculpture: forms are pared down to the essential and surface detail, whether in incision work or paint, is usually fairly minimal (though painted detail has often faded away). Nonetheless, the love of elaboration sometimes seen in the multiple vessels in pottery and stone also manifests itself in the marble sculptures, where paired figures may stand 55. 56 side by side or a small figure stand on the head of a larger one. Musicians playing pipes or 47 harps, other seated figures both male and 48. 86 female, figures shown with the baldric and 66 dagger of the 'hunter-warrior' – all these belong to the Keros-Syros sculptural tradition, and among them, as well as amongst the most accomplished of the straightforward folded-arm figures, are to be found the true masterpieces of Early Cycladic sculpture.

Figures that seem similar to the established folded-arm type but which retain some features of their predecessors are sometimes called 'pre-canonical'. In one example, the 37 arms are not completely folded and the delineation of the facial features recalls Plastiras examples. Such figurines represent a transitional type, and may in fact be roughly

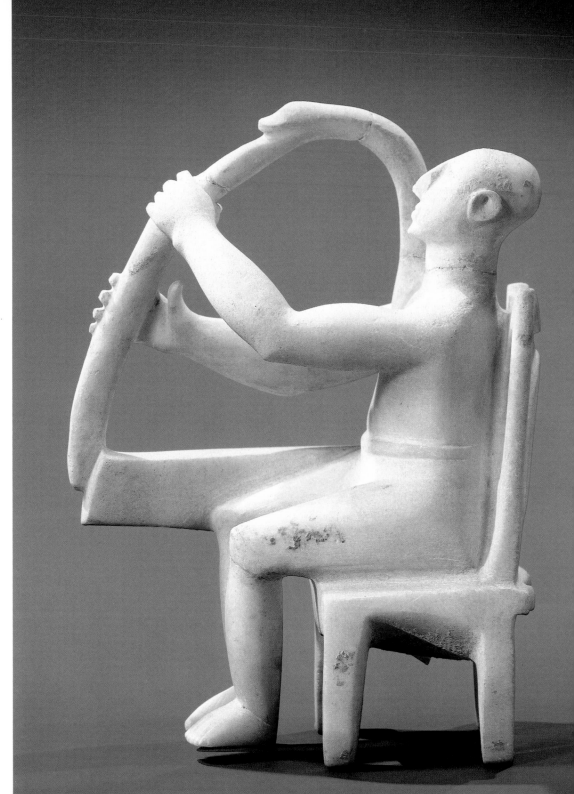

38 Marble sculpture of a harpist, of pre-canonical style. It is almost certainly the earliest example of this ambitious type. Transitional between the Grotta-Pelos and Keros-Syros cultures, about 2800–2600BC. (Metropolitan Museum of Art, New York, 47.100.1)

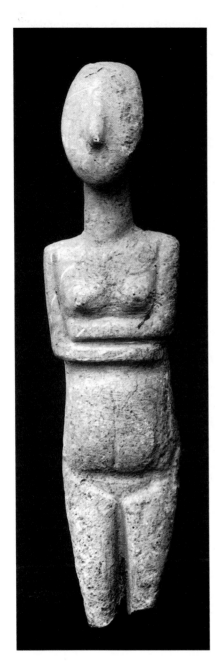

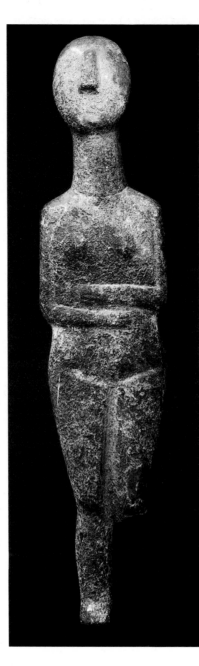

contemporary with the Louros variety. A further example is the harpist in the Metropolitan Museum of Art in New York, the authenticity of which has been doubted because of the naturalistic treatment of the arms, hands and face. In fact, it is precisely these features that indicate the pre-canonical nature of this figure.

The first of the classical 'folded-arm' figure types is known as the Kapsala variety. Already with this type the tradition is established that the right arm is folded below the left; with this type, too, though some still have horizontal feet, for the first time figures are definitely shown in a reclining posture. The heads tilt backwards, the knees are flexed and the toes slant downwards, so that they could not stand – a point worth stressing, since we are accustomed to seeing Cycladic figurines both displayed and illustrated in a 'standing' position. In fact, they lie down in self-contained repose, and in this are rather reminiscent of life-sized effigies on medieval tombs, resting for eternity with folded hands and neatly pointed feet. While we cannot with any certainty identify Cycladic figures as images of the dead (which some clearly were not), their posture does evoke funerary associations.

Kapsala figurines (named after a cemetery on Amorgos) are characterised particularly by rounded forms, naturalistic proportions, and a rather slim appearance generally, the shoulders scarcely wider than the hips. The legs are usually separated from the knee downwards, and the figurines are small, rarely exceeding 30 to 40 cm in height. The three examples in the British Museum include a rather apologetic-looking figure, another more robust one with the typically rounded head, and a third which is particularly fine. This figure is notable for its three-dimensional modelling, and the rounded contours are enhanced by the beautifully polished honey-coloured surface of the marble, which is remarkably well pre-

39 Marble figure of Kapsala type (about 2700–2600BC) of typically slim appearance. From Antiparos.
(*BM Cat. Sculpture* A21)

40 Marble figure of Kapsala type (about 2700–2600BC). The rounded shape of the head is particularly characteristic.
(*BM Cat. Sculpture* A20)

served. The slightly sloping forearms of the figure exemplify the fluidity of line sought by this sculptor, while the incised fingers show the interest in naturalism. It is indeed a pity that the head is missing.

Musician figures that can be associated with the Kapsala group include two harpists reputedly found together on Amorgos and a figure playing pan-pipes, now in the Badisches Landesmuseum in Karlsruhe.

The Spedos variety forms by far the largest group, evolving naturally from the Kapsala figurines in a seamless continuum that leaves some figures hard to define as belonging to one or the other category. The Spedos type includes sculptures in a wide variety of sizes, ranging from a diminutive 10 cm or less to nearly life-size (the largest known Cycladic figure, now in the National Museum in Athens, is 148 cm long and of Early Spedos type). Most of the elaborate group compositions and the musician figures belong to the Spedos variety.

Spedos figures differ from their Kapsala predecessors in having more defined outlines, a more pronouncedly geometric approach to body forms, and a much greater use of incision to show surface detail. They can be divided into an early and a late stage.

Amongst Early Spedos figures are some that tend, like their Kapsala predecessors, to have an angled profile caused by the backward tilt of the head and the bending of the knees. The leg cleft is usually perforated between the calves, the head is lyre-shaped and the arms are folded. Figures of this type usually have quite thick, stocky proportions and are of modest size. The pubic area is understated and no great emphasis seems to be placed on the sex of the figures, though almost all are female. Males are found amongst the musicians and group compositions.

Another group of Early Spedos sculptures includes most of those of unusually large size. They have a straight profile, with a flat front

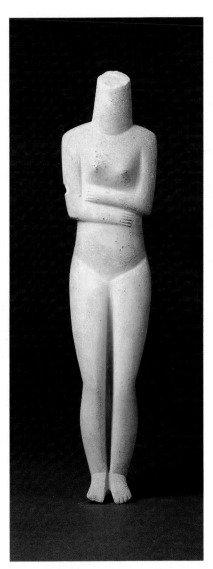

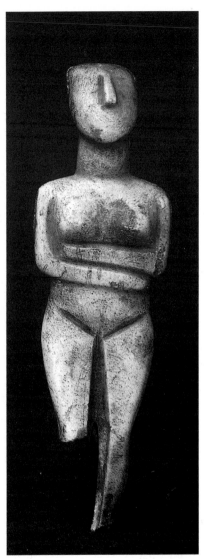

41 Marble figure of Kapsala type (about 2700–2600BC). This is a fine and well-preserved example, with smoothly rounded body and limbs. (*BM Cat. Sculpture* A25)

42 Marble figurine of Early Spedos type (about 2700–2500BC) with particularly stocky proportions. (*BM Cat. Sculpture* A24)

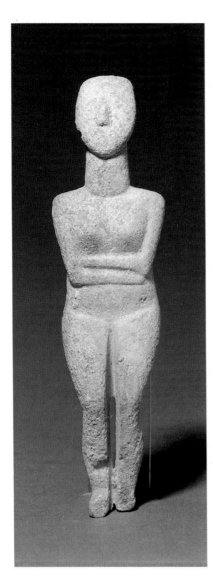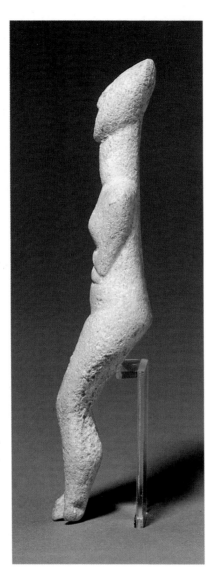

43 and 44 Front (*left*) and side views of an Early Spedos figurine (about 2700–2500BC). The angled profile characteristic of the type is so distinct that the figure is almost in a semi-sitting position. (*BM Cat. Sculpture* A23)

and back; the leg-cleft is again perforated between the calves, and the pubic area is simply set off by the relief of the tops of the thighs. Details often include carved ears and incised fingers, and these characteristics may derive from the large size of some such figures, which allowed room for such elaboration. It is not clear whether they are chronologically distinct from the group described above, or whether the differences arise from regional variation: the former are widely distributed throughout the islands, while this type seems to be limited to Keros, Naxos and Amorgos. 87

A typical example lacks its lower legs. Traces of red paint survive in the grooves at the top and bottom of the neck. The figure is of particular interest because a faint note in pencil on the back reads, 'Amorgo. Found with two others: flute player and Apollo in chair.' This was probably written by Greville Chester, who sold the figure to the British Museum in 1882. It is likely that the 'flute player and Apollo' are the two musicians now in Athens which were found together in a grave on the island of Keros. An early account states that two canonical female figurines were also found in this grave, but became separated from the group. Our figurine is almost certainly one of these: it has Amorgos rather than Keros written on it because Keros was (and is) a small, uninhabited island, so objects found there were taken to Amorgos to be sold. Figures such as the harpist and the double-flute player in Athens have always been difficult to date, precisely because grave groups were broken up in this way so that we do not know with what other perhaps more easily dateable objects they were found. By restoring their association with the figurine described here, we can confirm what had already been thought on stylistic grounds – that the Athens musicians belong to this Early Spedos group. 45 46 47. 48

The largest and also the finest figure in the back cover

British Museum belongs in this group. Measuring 76.5 cm in length, the sculpture is remarkably well preserved, even to the traces of red and black paint (probably originally dark blue) on its surface. Paint was used for almond-shaped eyes, eyebrows, some sort of diadem (perhaps of beads) around the brow, and a pattern of dots on at least one of the cheeks. The ears are carved as well as the nose, and the head has a typically elongated and flattened crown. This feature has not been satisfactorily explained, but sometimes hair is painted on to the figurines, and the shape of the head may be intended as a particular kind of hairstyle. The hands have incised fingers, the pubic area is set off by the curving relief of the tops of the thighs, and the legs are separated from just above the knee downwards to a bridge of marble that connects the ankles. The toes point downwards. As always in figures of this type, this separation of the legs represents a sort of technical bravura, as there is great danger that the legs will break during the carving process.

Seen from either the front or the back, the figure gives a rounded, pleasantly plump impression, and it is therefore rather surprising to see how flat it is in profile: the sculptor has released the form from the slab with great economy, producing a figure that is compact and sturdy.

The Late Spedos variety includes only female figures of folded-arm type. These vary widely in size but are not usually more than a metre tall. They have lyre-shaped heads and a straight profile, and have reached a stage where incision is the prime method of showing the bodily forms. Thus, for example, the leg cleft is no longer perforated but simply indicated by a deeply incised groove. A fully defined pubic triangle is amongst the details usually incised on the front of the figurines. Where perforations are few, the risk of damage is greatly reduced, and figures of this type are

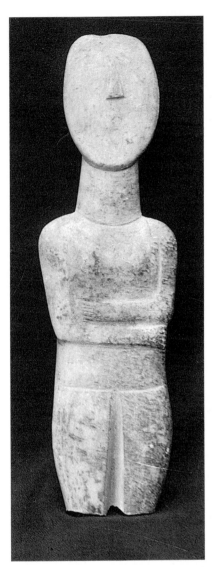

45 and **46** Front (*left*) and back views of the marble figurine of Early Spedos type which was found with the harpist **48** and double-flute player **47** now in Athens. (*BM Cat. Sculpture* A18)

43

47 and **48** Double-flute player (*left*) and harpist found together in a single grave on Keros. Related to the Early Spedos type (about 2700–2500BC). These male figures of musicians belong to rarely attempted, complex types and must be numbered among the very finest achievements of Early Cycladic sculptors. (National Museum, Athens, 3910 and 3908)

therefore the sturdiest and least prone to damage. The works of the 'Goulandris Master', represented in the Museum only by a single torso, belong to this group. They are discussed at greater length in Chapter 7.

Cycladic figurines were occasionally carved in materials other than marble, and an example in the Museum is of a vitric tuff (compacted volcanic ash), presumably from the island of Thera. The work is large (64 cm) and rather thickset and clumsy. It conforms in general to the Spedos type, but has the merest suggestion of breasts and no indication of the pubic triangle. The legs are ill-formed, terminating in abbreviated stubby feet, though the arms and fingers are carefully incised and the head, though damaged now, was quite neatly carved. The eyes seem to have been painted: the outline of the left eye, in particular, is clearly visible as a 'paint ghost'. This phenomenon occurs frequently on Cycladic sculpture, where the original presence of paint has preserved the surface of the stone from the effects of time, leaving it slightly raised and smoother than the surrounding area. The pigment itself has often entirely disappeared, and the effect is as if the painted areas had been carved in very low relief.

We can only guess what impulses led to the carving of Cycladic figures in materials other than marble, though one factor may have been that marble is not available in all the islands, so that other stones, shell, wood or even metal may have seemed attractive alternatives. In general, though, figures in other materials are rarely found, and those that have survived seem somewhat tentative and experimental. As well as the figurine made of compacted volcanic ash, which was acquired in Syros but probably made on Thera, the British Museum's collection includes a figurine made of lead. This came from Antiparos, and is one of only four known examples. It is small and rather shapeless, and displays none

 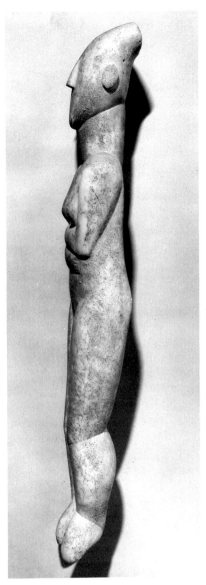

49 and **50** Back (*left*) and side views of the marble figure of Early Spedos type (about 2700–2500BC) which is also illustrated on the front and back cover. The sculpture is of considerable size and elaboration, and in a very good state of preservation. (GR 1971.5–21.1)

45

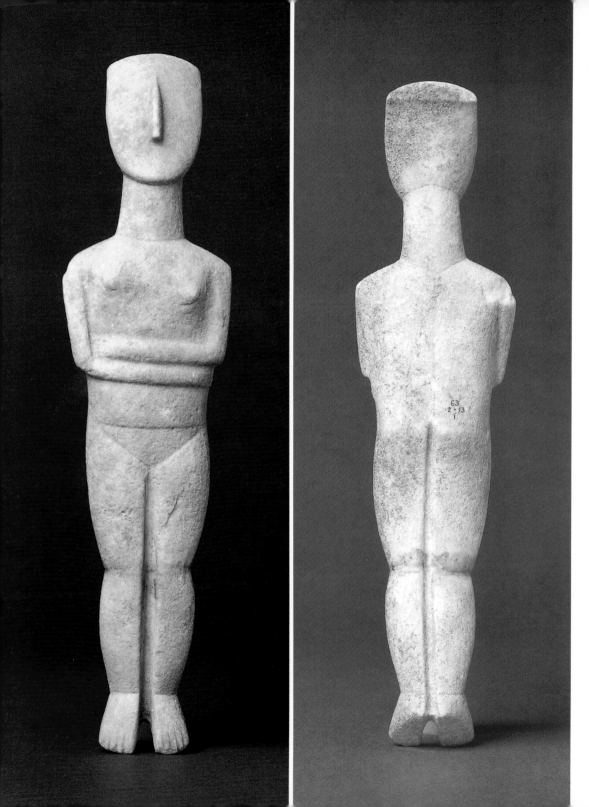

51 and **52** Front (*far left*) and back views of a marble figurine of Late Spedos type (about 2600–2400BC). This is a characteristic example: straight profile; lyre-shaped head tapering to a sharp point; high, unevenly placed breasts; wide pubic triangle with all three sides incised; and legs joined throughout their length and ending in separate, downward-pointing feet.
(*BM Cat. Sculpture* A17)

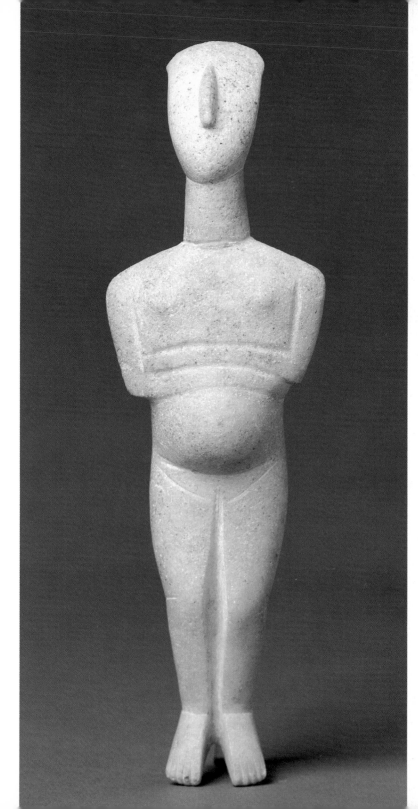

53 (*Left*) Marble figurine of Late Spedos type (about 2600–2400BC), clearly shown to be pregnant. Several pregnant Cycladic figures are known, though the condition is more marked than usual in this example. (GR 1932.10–18.1)

54 (*Below*) Figure of Spedos type (about 2700–2400BC), rather clumsily proportioned, carved from compacted volcanic ash from the island of Thera. Said to be from Syros. (*BM Cat. Sculpture* A19)

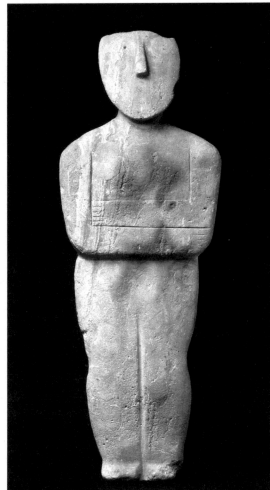

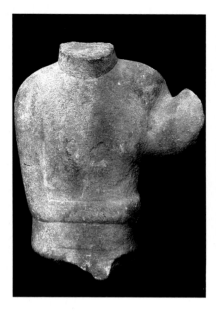

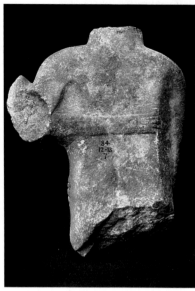

were shown side by side, each with an arm around the other's shoulders. This arrangement is paralleled by other fragmentary examples, but no complete group has survived. The nearest is the three-figure group in Karlsruhe, where two male figures stand in the position described, but support a seated female figure between them on their crossed arms. However, since it is fairly clear in the British Museum group that the arm on the left of the torso belongs to the missing companion figure, it would seem that there was not room between the two for a third, the angle at which the arms meet being too steep. The right arm, crossing the torso to terminate in incised fingers curling around the waist, is in the canonical position. The sex of the partly preserved figurine cannot be determined: there is a strange projection at the bottom of the torso, towards the top of where the left thigh should begin were it preserved, but it is difficult to identify this with male genitalia.

The next group, the Dokathismata variety, again develops naturally from the preceding Spedos type, with some transitional pieces having characteristics of both. With this type the tendency towards two-dimensionality becomes very marked, with flat figurines in which line, not modelling, is paramount. Proportions become exaggerated: not only are the figurines as thin as possible in profile, but they have wide shoulders and taper to narrow legs and feet. Tautness of form and sharp precision of line characterise the finest Dokathismata examples. Incision work is neatly done, and the figures are balanced and symmetrical.

With the Chalandriani type, Cycladic folded-arm figures came to an end, and it is therefore not surprising that this variety sees the disintegration of the tradition that had lasted for about five hundred years. Non-canonical elements are introduced into the design of the figurines, while a certain carelessness creeps

of the technical expertise shown by other metal-work of the time. The possibility that wooden figurines were extensively used has sometimes been suggested, and certainly these would leave no trace in the archaeological record. However, if a more readily available and more easily worked substitute for marble had been sought, one might expect to find some use of clay, which actually does not seem to have been used for figurines. It appears, then, that their production belonged quintessentially to the world of sculptors in marble, and that the close connection between the material and the form that we admire on aesthetic grounds today was also valued by the people who made and used them, though not perhaps for the same reasons.

A fragment of a group composition is preserved in the British Museum and should doubtless be included with the Spedos type, though unfortunately only the torso of one figure and part of the arm of another is preserved. It seems that originally two figures

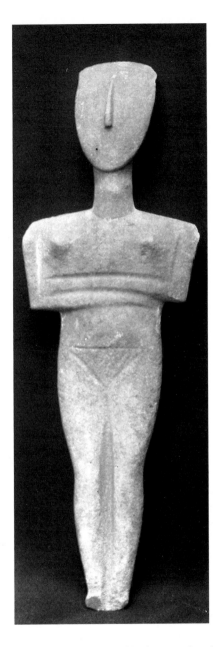

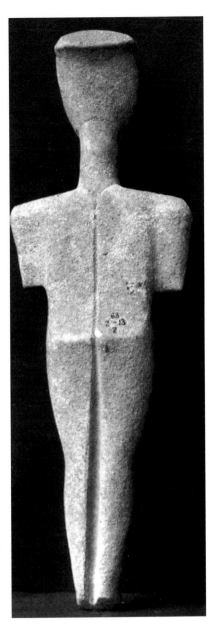

57 and **58** Front (*left*) and back views of marble figure of Dokathismata type (about 2500–2300BC). It is typically slim in profile and has exaggeratedly wide shoulders. (*BM Cat. Sculpture* A15)

into their execution. At first, however, the type probably overlaps with Dokathismata examples chronologically, and some pieces have features of both. An example in the Museum still retains Dokathismata elements in its proportions and style, though it approaches the more squat Chalandriani shape. It also exhibits a non-canonical feature in the group of grooves or folds incised on the abdomen. The significance of these is not entirely clear, but it has been suggested that they represent the wrinkling or folding of the skin directly after childbirth and may be another indication that Cycladic figurines were especially connected with fertility, or perhaps more specifically with a difficult and dangerous time in a woman's life.

Typically, Chalandriani figurines are small, and very flat in profile. Their squat appearance is often due to the fact that, while the shoulders are wide, the bodies lack a mid-section, and the folded arms lie directly above the pubic triangle. A typical example shows how the tradition that had previously been so rigorously adhered to is beginning to break down – the figure has its arms folded in a previously almost unthinkable arrangement, with the right above the left.

A non-canonical arm position also occurs in a third example of the Chalandriani type, which is very noticeably broad and flat, and rather carelessly executed. While the right arm lies across the front of the figure in the usual way, the left crosses the chest diagonally. The perforated spaces between the upper arms and the body occur on other examples of this type. Like all such perforations, they would be technically quite difficult to achieve, particularly on such a thin figure, and as such sit rather oddly with the carelessness exhibited in other respects. The fingers, for example, are scratched on in a most untidy way. As is usual in this variety, the short legs are separated only by a superficially incised groove, and the

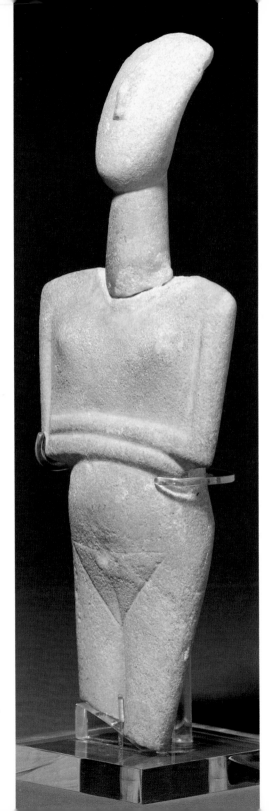

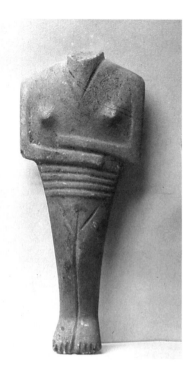
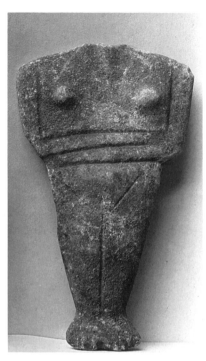

59 (*Left*) Three-quarter view of an elegant marble figure of Dokathismata type (about 2500–2300BC). Even such thin, angular figures were sometimes shown in a state of pregnancy, and in profile the swollen abdomen of the figure is very marked. A drawing of this piece, dating from 1850 when it was in a private collection, shows the lower legs, but they were already detached and were lost before the figure came to the Museum. (*BM Cat. Sculpture* A16)

60 (*Above left*) Marble figurine with elements of both Dokathismata and Chalandriani types (about 2500–2200BC). The unusual grooves across the abdomen may indicate wrinkling of the skin after childbirth. (*BM Cat. Sculpture* A13)

61 (*Above right*) Marble figurine of Chalandriani type (about 2400–2200BC), with arms folded in a non-canonical position, the right above the left. (*BM Cat. Sculpture* A12)

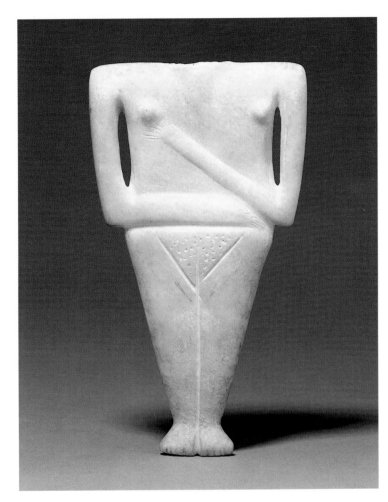

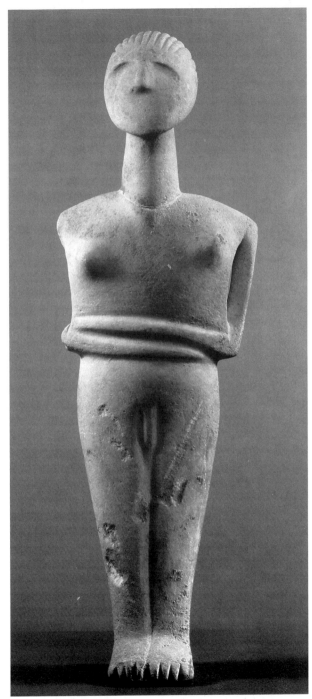

62 (*Above*) Marble figurine of Chalandriani type (about 2400–2200BC), with non-canonical features including the unusual position of the arms and the dotting of the pubic triangle. (*BM Cat. Sculpture* A14)

63 (*Right*) Male figure with proportions related to the Dokathismata type, and a grooved hairstyle found on several male examples dating from the latest period of figure production. About 2500–2200BC. (Metropolitan Museum of Art, New York, 1972.118.103)

feet are short and rather formless. In some cases, the feet of Chalandriani figures seem once again to be flat on the ground, as if the figures are in a standing position. The curious dotting of the pubic area is found on just one other example, and may be a stylised rendering of pubic hair.

63 Male figures reappear with the Dokathismata and Chalandriani varieties, and these often display unusually elaborate carving of the facial features and hair. Some belong to the type known as the 'hunter-warriors', so called because they wear a baldric slung diagonally from one shoulder and are often armed with
66 daggers. A fine example of a hunter-warrior in the Goulandris collection is of particular interest because he is paired with a 'matching' female, very similar in style and proportions, with which he is said to have been found, probably in a grave on Naxos. This pair is unique amongst surviving Cycladic figurines, but the fact that another closely similar pair once existed (and perhaps still does, some-
64, 65 where) is proved by drawings in the British Museum dating from 1848, showing another hunter-warrior and his female companion when they were in a private collection. The style and proportions of these four figurines associate them with the Chalandriani type, but the full carving of the facial features and hair, as well as the baldrics and daggers, places them in a small and unusual late group.

67 It is with such pieces as these – interesting, indeed, but lacking the sublime harmony of material, proportion and style achieved by the Early Cycladic sculptors at their best – that figure production effectively came to an end.
15 Schematic examples seem still to have been produced on a limited scale in the succeeding period, but by then the wind of change was blowing in the islands. They were to be famous again for their fine marble and for their sculptors, but by the sixth century BC, when works of island marble were in demand for

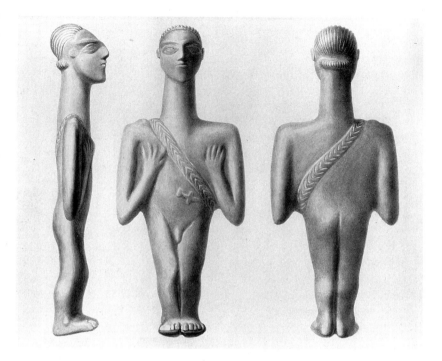

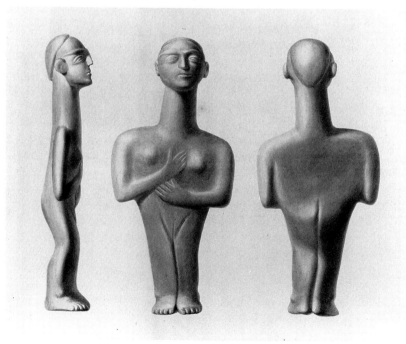

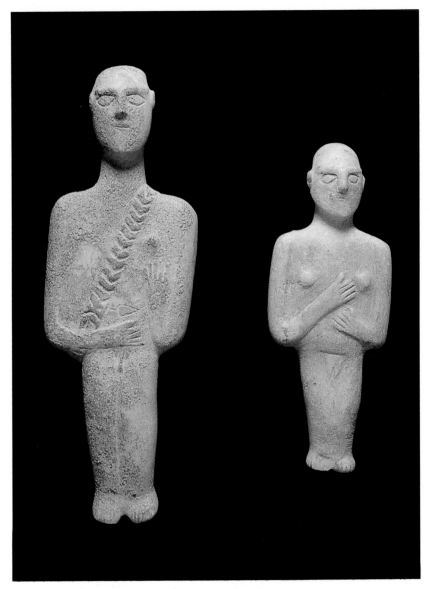

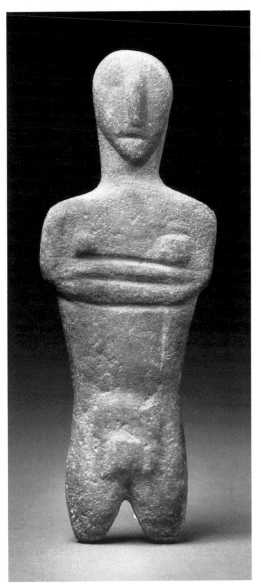

64 and **65** (*Left*) Two drawings showing a lost pair of Cycladic figurines similar to the Goulandris 'hunter-warrior' and his female companion **66**. (GR 1955.8–20.9 and 10)

66 (*Above*) Male figurine of 'hunter-warrior' type with baldric and dagger, and a female companion piece said to have been found in the same grave. About 2400–2200BC. (N.P. Goulandris Foundation, Museum of Cycladic and Ancient Greek Art, Athens, 308 and 312)

67 (*Above*) Marble figurine with post-canonical features. The pubic area is apparently unfinished, and the figure was perhaps intended to be male. (*BM Cat. Sculpture* A33)

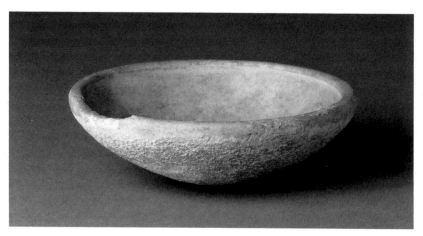

68 (*Above*) Plain marble bowl. Keros-Syros culture, about 2700–2200BC. (GR 1854.12–18.20)

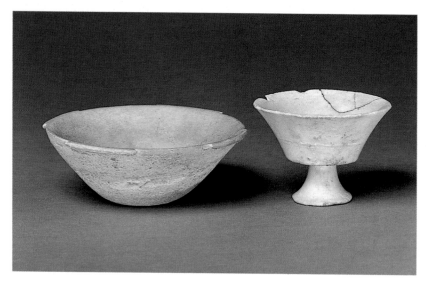

69 (*Above*) Marble bowl with four lugs at the rim, and marble-footed goblet, both of the Keros-Syros culture (about 2700–2200BC). From Antiparos and Chalandriani on Syros, respectively. (GR 1884.12–13.5 and 1912.6–26.11)

dedication at all the major sanctuaries of the Greek world, the Early Cycladic sculptors, forerunners of this great tradition, were long dead and long forgotten.

Marble vases

Frequently less regarded but nonetheless an impressive aspect of Keros-Syros marble working was the production of vessels. Presumably the sculptors of the figurines also carved these vessels, which at their best again reveal a mastery of the material combined with an appreciation of harmonious form. As in the case of the figurines, this phase is characterised by a much wider variety of types, ranging from the simple to the very elaborate. Vessels in chlorite schist, a sort of soapstone which is softer than marble and much easier to carve, were also made.

By far the most frequently found vessels are simple shallow bowls, usually with slightly 68 thickened rims and a small circular flattened area on the base, presumably to aid stability (though in spite of this such bowls are often not very stable). They vary in size, although most are quite small, and the very plain, straightforward shape is the perfect vehicle for showing off the fine qualities of the island marble. There are several examples in the British Museum. A fairly common and very elegant variant has four horizontal lugs evenly 69 spaced around the rim. The interiors of such bowls are sometimes painted red or blue, while some seem to have been put into the grave actually as containers for colouring matter. Their humbler counterparts in clay were probably generally used to contain foodstuffs, but with marble examples there is always the possibility that they were made specially for the grave.

Rectangular palettes are once again found in this phase. Some are quite flat, with a raised rim, while one example in the collection is 70 deeper and has a single horizontal lug. These

also sometimes show signs of having had pigments ground or prepared on them, perhaps with the marble pestles also found in some graves. Since colouring matter is such a common feature of the grave groups and, as we have seen, the figures often bore elaborate painted patterns, particularly on their faces, one wonders whether the faces of the dead were not also painted as part of the funerary ritual, and the means for doing this then buried with them.

Footed vessels were made in marble, and often the addition of a foot to a fairly straightforward shape created something considerably more elaborate. An example is a drinking goblet: a simple conical shape is combined with an elegant pedestal similar to, but rather more curvaceous than, the pedestals of footed vessels of the preceding phase.

With the pyxides, or lidded boxes, we move out of the realm of vessels that might have held food and drink (though they may have had other functions, too) and into that of containers, perhaps for jewellery or small objects, perhaps for cosmetic preparations. The spherical pyxis was a popular type. These typically have neatly fitting lids, flanged on the underside to create a tight fit, and a pair of pierced lugs at the widest point of the body. Strings passed through these would have held the lid in place, though the lids themselves do not usually have string holes. The fragment of a spherical pyxis made from dark red stone, in the probable tomb group discussed on p.42, belongs to a variant with closely spaced vertical grooves running around the body.

The second type of pyxis is known as the spool pyxis because of its distinctive shape. The cylindrical sides of the vessel are carved with encircling grooves and the top more or less matches the base, thus achieving the symmetrical spool shape. Holes pierced in the lid could be used to hold it in place.

Similar encircling grooves can be seen on

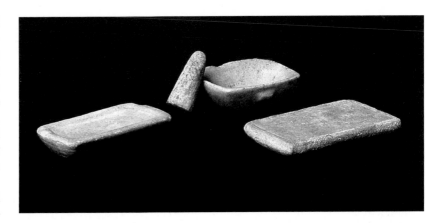

70 (*Above*) Marble pestle from Amorgos and three marble palettes of unknown provenance, perhaps used for grinding pigments. Keros-Syros culture, about 2700–2200BC. (GR 1884.12–13.74 and 1933.10–16.1, 2 and 3)

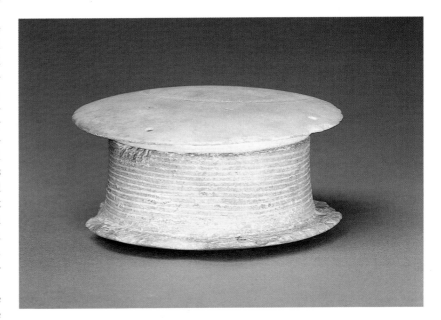

71 (*Above*) Marble pyxis (box) with lid, of the type known as a spool pyxis because of its distinctive shape. Keros-Syros culture, about 2700–2200BC. From Syros. (GR 1842.7–28.614)

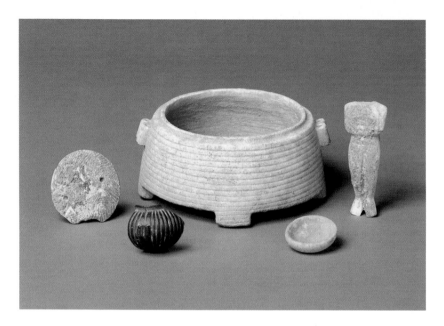

72 the hut pyxis, a marble vessel of particular interest which came to the Museum with four other objects said to have been found in the same grave. As four of the five are stone vases, or fragments thereof, the group may properly be included here. The fifth piece is a small figurine of Late Spedos type which perhaps provides the best dating evidence for the group, though it should be stressed that there is no real evidence that these pieces genuinely were found together, even though the association is perfectly plausible.

The hut pyxis, then, derives the name from its footed shape. All the other known examples are carved not of marble, but of chlorite schist, and often in these the resemblance to a hut is more explicit: the example in the British Museum suffers, moreover, from the loss of the lid. While elaborate spiral designs are common on hut pyxides of softer stone, the encircling grooves of this example bring it close to the 71 spool pyxides, though the shape is, of course, quite different, with inward-sloping walls and paired lug handles. The vessel has a hole in the bottom which seems to have been made deliberately. This feature is seen on some other Early Cycladic stone vases and is perhaps an example of ritual practice, where the vessel is fitted for the realm of the dead by being 'killed' or deprived of its real function (as in the practice of 'killing' swords by bending or breaking them, attested in later Greek burials).

Metal-work

The number and quality of metal finds of the Keros-Syros phase is quite remarkable in view of their extreme rarity in the preceding period. Tools and weapons were cast from good-quality arsenical copper, as were smaller toilet items, while silver was used for vessels and jewellery, and figurines and boat models were 2 made of lead. Developments in the Cyclades were in line with those elsewhere in the eastern Mediterranean, where metallurgy reached a remarkably advanced stage in the Early Bronze Age, and influences from both Crete and Anatolia can be seen in the islands.

The impact of increased skill in metal-working and the increasing availability of metal tools must have revolutionised certain practical aspects of island life, bringing potential advantages for agriculture and fishing, building, ship-building and carpentry, marble carving, hunting and even fighting. The presence of jewellery and toilet articles, as well as such purely luxurious items as silver vessels, shows 74 that the society had reached a stage when there was a demand for non-essential items, and specialist craftsmen could be supported while they produced luxury goods.

The picture in metal-working, as in other aspects of craft production in the Keros-Syros phase, is thus one of advance and proliferation. However, it should be remembered that the total number of metal objects known is still not very large. They must always have been rather rare and valuable objects for the early islanders and, as we have seen, tools of

72 Probable tomb group of the Keros-Syros culture, including a small figurine of Late Spedos type, a marble hut pyxis, a small marble bowl, a fragment of a grooved spherical pyxis in dark red stone and a green stone lid. The lid is like Minoan examples, but at least one parallel from the Cyclades is known. About 2700–2200BC. (GR 1969.10–1.1, 2, 3, 4 and 5)

73 Pair of copper tweezers from Antiparos. Keros-Syros culture, about 2700–2200 BC. (GR 1884.12–13.26)

obsidian continued to be used in considerable numbers alongside their metal equivalents.

The Cyclades, with their sources of copper, lead and silver, were able to support the entire process of metal-working from the extraction of the ore to the finished product, so while some techniques and types produced were imported, many seem to have been purely Cycladic inventions. Evidence has recently been collected for early exploitation of the silver and lead mines of Siphnos, and of the copper sources of Kythnos. Smelting was probably carried out as near as possible to the mines, to avoid lengthy journeys with the heavy ore.

The only evidence for the casting of tools and weapons has come from Kastri on Syros, where remains of furnaces and crucibles were found along with clay and stone moulds for such items as axes and spearheads. The molten metal would have been poured into the one-piece mould, with the eventual shape of the object finished by hammering. Bronze objects from Kastri, typical of the Kastri group, have been shown by analysis to be made of tin-bronze, and to be close in composition to Trojan examples. Finished objects and perhaps also raw materials thus seem to have been imported to Kastri along with the Anatolian pottery types characteristic of this group.

Cast tools are represented in the British Museum by ten axes and chisels made of arsenical copper, previously known as the Kythnos Hoard. Recent research has shown that, although ore from Kythnos was used in the manufacture of all ten tools, eight of them were actually found on Naxos as part of a larger hoard; other items from this hoard are now in the National Museum, Copenhagen. The tools were probably used for wood-working: heavy-duty shaft-hole axes for felling trees and stripping branches, chisels for finer work. The large flat axes, a typically Cycladic product, may have been used as wedges to split tree-trunks into planks.

Other tools used by the islanders included knives, awls and needles, as well as agricultural implements and fish-hooks.

The Museum's collections include no toilet articles, except for a solitary pair of tweezers from Bent's excavations on Antiparos. These were badly out of shape and described only as a 'flat band of copper', but they have recently been recognised and restored to something like their original form. Such tweezers, a typically Cycladic type, were frequently included in graves, and spatulae and razors are also sometimes found.

Cycladic jewellery could be quite elaborate and included diadems with repoussé or cut-out decoration, necklaces of beads in a variety of shapes and materials, and a fine range of dress pins, sometimes with animal-shaped heads. Jewellery is represented in the British Museum by a silver torc and four silver bracelets, also found by Bent. These are very simply made and unfortunately in rather poor condition. The torc consists of a length of silver, square in section, that has been twisted to give a decorative effect before being curved into a circle that would fit very exactly round the neck. The bracelets are plain circles of

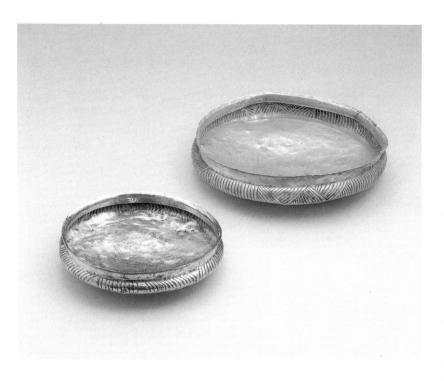

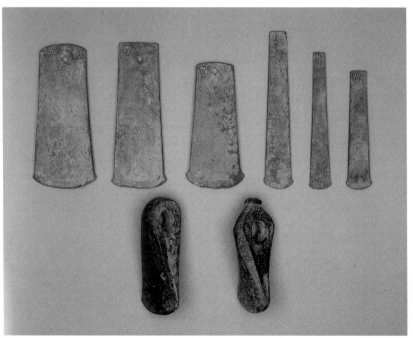

74 (*Above left*) Two silver bowls of Cycladic workmanship, said to have been found in Euboea. Keros-Syros culture, about 2700–2200BC. (Metropolitan Museum of Art, New York, 1972.118.152 and 46.11.1)

75 (*Left*) Part of a hoard of wood-working tools, now known to have been found on Naxos. Keros-Syros culture. (GR 1969.12–31.1, 2, 3, 4, 5, 6, 7 and 8)

76 (*Above*) Lead figurine from Antiparos. About 2800–2200BC. (GR 1884.12–13.20)

77 (*Above right*) Silver torc and four silver bracelets from Antiparos. Keros-Syros culture, about 2700–2200BC. (GR 1884.12–13.21, 22, 23, 24 and 25)

78 (*Right*) Dagger with pronounced midrib. About 2400–2200BC. (N.P. Goulandris Foundation, Museum of Cycladic and Ancient Greek Art, Athens, 242)

silver, bent so that the ends overlap. They are very small, perhaps of a size that could only be worn by a child.

76 The lead figurine mentioned on p.45 is the only example of this metal in the collection,
2 though a boat model found on Naxos is now in the Ashmolean Museum in Oxford. The form of the boat, with a high prow, is reminiscent of
33 those seen on the frying pans, and such models underline the importance of the sea and seafaring to the early islanders.

 Spears and daggers seem to have been the weapons most frequently carried. The daggers
78 typically have a pronounced midrib, while the spearheads have plain tangs and long slots for binding the head to the shaft.

 The Keros-Syros phase came to an end under obscure circumstances, and its relationship to the Phylakopi I culture which followed is a controversial question. While the pottery, for instance, shows elements of continuity, marble-working dies away completely. This

was a great loss, and in most aspects of material culture the Keros-Syros achievement was unequalled – certainly unsurpassed – by anything produced in the islands during either the earlier or the later stages of the Bronze Age.

6 End of an era: the Phylakopi I culture

From few Aegean sites of the pre-Hellenic period, if indeed from any, has there come a more interesting collection of pottery than from Phylakopi in Melos.

C. C. EDGAR

The Phylakopi I culture, named after the earliest levels of the town site on the island of Melos, dates from about 2200/2100 – 1800BC and can be described in Cycladic terms as the last of the Early Bronze Age culture groups. It is, however, largely contemporary with the earlier part of the Middle Bronze Age on the Greek mainland and in Crete, and in many respects looks forward to what is to come rather than backwards to what has already been.

In this phase, settlements were once again in seaside locations and unfortified. It seems likely that on most of the islands the population grouped together and lived in larger, more well-organised towns. This is certainly true on Melos, which becomes virtually a one-site island. Most of the population must have moved to Phylakopi itself, where the site seems more truly urban than before, being both more extensive and having houses that are more carefully arranged and more solidly built.

While cist graves continued to be used in some areas, rock-cut tombs were also introduced in this phase.

Pottery takes on a new lease of life and is particularly well represented in the British Museum's collection. Metal-work, though not well known, presumably also continued to flourish. However, the tradition of marble-carving has largely died out. Only a few very plain schematic figurines seem to have been produced, and marble vessels were no longer made. This in itself indicates a major change from the preceding Keros-Syros culture.

Phylakopi I pottery is characterised by an increase in the use of painted decoration and a love of fantastical shapes, both well represented in the multiple vessels known as cluster vases or 'kernoi'. The Greek word *kernos* implies a ritual use for such vases, which may have been used to offer small quantities of different sorts of produce to the deity. The painted decoration is typical of this phase, which sees the use of dark paint applied over a light slip. Designs are usually rectilinear.

Dark-faced pottery continued to be made, with either incised or relief decoration. The former can be seen on a 'duck vase' – an example of this typical shape also known as an 'askos', and bearing some relation to vessels made of animal skins. A somewhat similar jug, with a high, leaf-shaped spout bent backwards towards the handle, is also typical. It is decorated with paired vertical bands in low relief.

With the advent of the Phylakopi I culture the islands entered into a new age. Increasing contact with Minoan Crete and later with the Mycenaeans of the Greek mainland brought the Cyclades continuing prosperity, and they continued to have a part to play in the developing Bronze Age world of the eastern Mediterranean. Nonetheless geography, which for a millennium had given them an advantage, now began to work against them. Essentially small and fragmented by nature, they could scarcely resist the overwhelming influence of their larger and better organised neighbours. The Cyclades were never again to see a culture so distinctive and influential as that which flourished in the Early Bronze Age.

79 Pottery *kernos* (multiple cluster vase). Phylakopi I culture, about 2200–1800BC. (*BM Cat. Vases* A344)

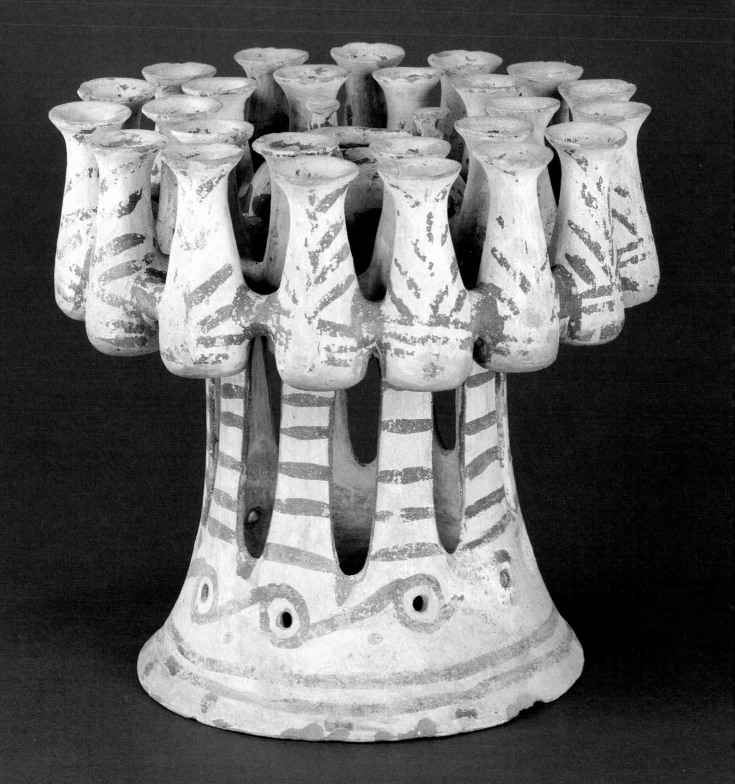

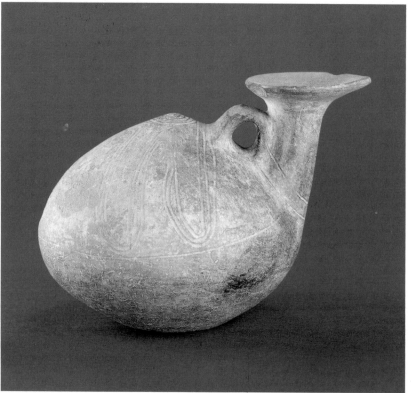

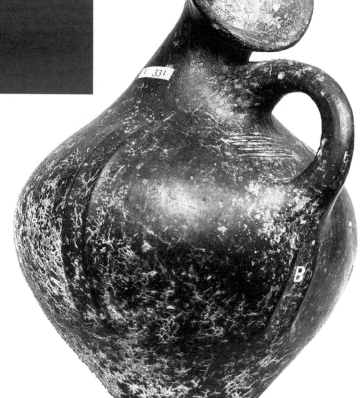

80 (*Above*) Pottery 'duck vase' or *askos*. Phylakopi I culture, about 2200–1800BC. (*BM Cat. Vases* A330)

81 (*Right*) Pottery jug with upturned, leaf-shaped spout. Phylakopi I culture, about 2200–1800BC. (*BM Cat. Vases* A331)

7 Cycladic sculptures

The maker has to have a reason for making the object, whether that reason is to propitiate the gods, or to stir the soup. An idol is as functional an object as a spoon.

MARTHA HEATH WIENCKE

An examination of the way in which Cycladic figures were made not only enhances our appreciation of the sculptures themselves, but is also potentially revealing in terms of the nature of Early Cycladic society. For example, it is interesting to consider whether figures were carved by specialist sculptors, and if so how many such specialists were supported by the community and at least partly released from the rigours of making a living from the land. The distribution of those sculptures that can be attributed to individual sculptors may tell us something about trade and travel within the islands. A better understanding of the way in which the figures were made might also throw some light on the difficult question of their significance for the early islanders.

Certain elements of figure production have been much illuminated by recent research and study. These fall broadly into three categories: the design of the various figurine types; the techniques used in their production; and the way in which the individual sculptors related to the tradition within which they worked.

It is clear that the production of Cycladic figures was a very traditional matter. While the most simple schematic examples have scarcely evolved from beach pebbles, those of more complex form, such as the violin type, show a degree of uniformity, and by the time of the 'classic' Kapsala and Spedos varieties there is clearly a very strong element of tradition in the way they are made. This means that all the figures belonging to each different type are very similar to each other, an effect that is striking in a large exhibition or when viewing a large number of illustrations of figurines. The cynic might say, 'Seen one, seen them all'; the sculptor Henry Moore put it more elegantly when he remarked, 'It's as if they couldn't go wrong, but arrived at a result that was inevitable from the very beginning.' Some of this inevitability has been shown by recent analysis to arise from the application of certain formulaic proportions and angles in the design of the figures. These were the basics of the tradition, handed down over generations, perhaps from sculptor father to apprentice son.

Planning, then, was essential for all but the very simplest of figure types, and must have involved marking up the original piece of marble before the carving was begun. This could have been achieved by scratching marks with a sharp piece of obsidian or by the use of charcoal, but some basic measuring devices would also have been required. These may have included simple versions of rulers and protractors, and perhaps compassses created by attaching a piece of charcoal to a string. Using these, the desired proportions and angles could be laid out on the top of the slab and the stone then worked accordingly. Such an approach would account for the strongly frontal aspect of most Cycladic figures, where the side and back views are relatively neglected.

Plastiras figurines were generally divided into three equal parts – head and neck, body, and legs – while for the Spedos type, a four-part division was used, often with each part being equal in length to the widest dimension. These divisions were perhaps marked out by charcoal-and-string compasses, as the arcs of a circle seem to be mirrored in such features as the curving lines of the shoulders, tops of heads, and toes.

Arcs were less important in the more angular Dokathismata and Chalandriani types. While four-part divisions were still used for such figurines, experiments were also made with three- and five-part divisions – perhaps not surprisingly at a time when the previously rigid conventions were beginning to decline.

Elaborate seated figures such as the harp players seem, as one might expect, to have been even more carefully planned, probably with a grid laid out on each of the four sides. The right-hand side – that with the harp – was

treated as the most important, and the grid seems to have been based on the usual four-part division of height, the depth being equal to three such divisions.

A further traditional design element contributing to the sense of harmony of Cycladic figures of various types is the repeated use of particular angles. These were applied to the outline, in such features as the angle formed by the shoulders, as well as in internal incisions, such as those delineating the pubic triangle.

This brief outline of some of the principles adopted by Cycladic sculptors shows that theirs was a sophisticated craft, depending on the application of what are sometimes termed 'canons' of proportion, arrived at over years of cumulative experience. While the essential principles may be simple enough, it is nonetheless clear that specialist knowledge was involved, and it seems overwhelmingly likely that the island sculptors were specialists, though not necessarily on a full-time basis.

Before leaving the question of design of sculptures, it should be stressed that sometimes things went wrong. Only about half of all known figures actually seem to conform closely to observable canons. The design of some others may have started out canonical, but breakage during manufacture may have forced changes to be made. Some sculptors deliberately introduced variations, while others seem scarcely to have planned their figures at all. The products of the latter are, not surprisingly, inferior, and it may be that here we see the non-specialist at work, perhaps producing 'cheap imitations', or someone forced by circumstances to attempt a task not normally his own.

Turning to technique, recent experiments designed to produce modern figurines based on Cycladic examples, using only tools made of materials that would have been available to ancient sculptors, have produced some very interesting results. For example, it has proved quite possible to produce figures satisfactorily using only stone tools. Certainly the figurines of the Grotta-Pelos phase (schematic, Plastiras 15 and Louros) must have been made without metal tools, which they largely predate, and in fact stone tools work remarkably well. An emery hammer could have been used to block out the marble to the basic size and shape required. Smaller emery tools could then be used to chip at the stone until the shape was roughly formed, as well as to abrade the surface of the marble when slower progress was required as the shape was refined. During the experiment, obsidian proved useful for incision work and for 'shaving' the surface of the stone to remove unevenness. Pumice was used for final polishing and to impart a soft sheen. None of the tools used needed special shaping, and the (untrained) sculptor was able to produce three very passable figurines of violin, Louros and Spedos type in five, thirty and sixty hours respectively.

The advent of metal tools in the Keros-Syros phase may have helped both to speed and refine the carving process, but in general it is clear that patience must have been almost as important as skill for the Cycladic sculptor. The modern sculptor no doubt took longer to complete each figure than a practised ancient craftsman, but very straightforward types were attempted, and they were not made as thin in profile as their ancient counterparts. Without doubt, the larger and more refined figure types represent a very considerable investment of time and energy. Nonetheless, it is certainly true that the known total of Cycladic figures, and the level of demand indicated by their relatively infrequent appearance in graves, seems to suggest that the number of sculptors may have been fairly small. Part-time working, and the fact that the sculptors of figurines presumably also carved the marble vessels, naturally would have

affected the output of the individual sculptor, but it seems unlikely that workshops, where several sculptors could work side by side, ever existed. It is more probable that communities of reasonable size on the islands supported one or two sculptors, perhaps a master and an apprentice. The bigger islands such as Naxos and Paros, which are also rich in marble, might even on this basis have supported enough sculptors at any one time to allow some interchange of ideas and influence, but the smaller islands probably did not. Those without any marble presumably had no sculptors but simply imported their figures. There is evidence that the work of individual sculptors appears on different islands, showing that the figurines, and possibly the craftsmen themselves, could move from island to island and perhaps even further afield. Interesting in this connection is a site on Keros, a small and inhospitable island that could not have supported a large population, where several hundred figurines and fragments were found, along with fragments of marble vases. The vast majority of these must certainly have been imported, and the island does have a good harbour. It is far from clear whether the site was a cemetery, a sanctuary, or some kind of (ritual?) dump: it had been looted before archaeologists began working there and still needs further investigation.

Pioneering work on many aspects of figure production, but particularly on the attribution of Cycladic sculptures to specific hands, has been achieved by Pat Getz-Preziosi. It might at first seem strange that such attributions are possible since, as we have already seen, the production of the various types of figures was such a conventional matter and there were so many traditional elements in their design and manufacture. Nonetheless, the figures are obviously not identical, and in fact a great range of subtle variations could be introduced within the basic types. The attribution of

figurines to hands on stylistic grounds, then, depends on the recognition of recurring groups of such variations, which are characteristic. Sometimes two sculptures are virtually identical, but in other cases a group of works that have been attributed to one hand show variations that may be the result of different stages of a sculptor's career.

A sculptor to whom a large number of works has now been attributed is known as the Goulandris Master, after the collection which contains two fine complete examples of 83 his work. A torso in the British Museum can 82 also be attributed to his hand. His output seems to have been remarkable: up to one hundred figurines have so far been recognised, of which fourteen are complete or nearly so. This total amounts to a significant proportion of all Cycladic figures now known and estab-

82 (*Right*) Torso attributed to the Goulandris Master. Late Spedos type, about 2600–2400BC. From Amorgos. (*BM Cat. Sculpture* A22)

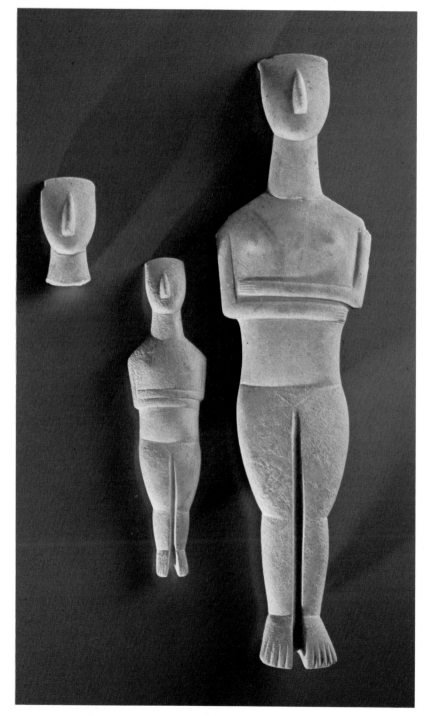

lishes the Goulandris Master as the most prolific as well as one of the most skilful sculptors of his age.

His figures are of the Late Spedos variety and exhibit features, which, in combination, make up his personal style. According to Getz-Preziosi, these include 'a long semi-conical nose on a lyre-shaped face with painted decoration; markedly sloping shoulders; parallel and precise incisions curving gently at the neck, abdomen, knees and ankles; an unperforated leg-cleft; a rounded back, with no indication of a spine; and a general rounding of the profile surface.' However, it is difficult to describe in words those characteristics which immediately strike the eye and distinguish the works of this hand.

Goulandris Master figurines are known to have come from Naxos, Keros and probably Amorgos, though many have no certain provenance. It is very likely that he lived and worked on Naxos, an island that, along with Paros and Amorgos, seems to have been at the centre of figure production and would be a likely home for a craftsman of his undoubted stature.

Significance of the figures

Marble figures were made in certain well-defined types for a period of some eight 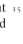 hundred years. Why were they made, and what was their significance?

There can be no definite answer to these questions, because almost no general statement can be made about the figurines that does not carry some exceptions. Thus most are female, but some are male; most were found in graves, but some come from settlement sites; and so on. Any suggestions must be more or less speculative, but some are more likely than others, so it is worth considering what we actually know, and what can safely be said.

Firstly, it seems certain that the figurines

were important to the early islanders. The persistent tradition of their manufacture seems to indicate this, as does the fact that they were made of marble – a high-quality, durable material that was time-consuming to work. These factors alone seem to dismiss trivial interpretations of the figures as dolls or toys, and in any case there is no evidence that they were placed in the graves of children.

It seems very likely that the schematic figure types generally represent abstract versions of the naked female form of the naturalistic types, and therefore the two can be considered together from the point of view of interpretation. Both types have been found mainly in graves, and certain features of the folded-arm figurines, in particular, evoke funerary associations. Their reclining posture and quiet inactivity are perhaps the most notable of these, and while their folded arms may partly have evolved because such a position was easy to carve and reduced the risk of breakage, it must still have been considered appropriate in terms of what the figures represent.

One might add the possible connection between painted decoration on the figures and the use of paint in funerary ritual, if we can assume that this is the reason for the frequent presence of colouring matter in graves. It may also be significant that on figurines where paint or paint ghosts are well preserved, there is rarely any indication of a painted mouth: perhaps a symbolic equation is being made between speechlessness and death.

Funerary associations, then, are very striking. Generally speaking, we know that in ancient societies figures were put into graves for a variety of reasons. They might be servants who would attend the dead in the after-life, sometimes with special roles – female figures might be concubines, musicians might play for the deceased, and so on. Alternatively, they might be personal possessions, thought to protect the owner in life before accompanying him or her to the grave. As such they might represent their owners, or a deity.

It is difficult to choose between the various possibilities since unfortunately we lack vital analysis of skeletal remains from Cycladic graves that would enable us to correlate the age or sex of the deceased with the figure types buried with them. If we had this information, some explanations could be excluded – it is assumed, for example, that females would not be buried with concubine figures, nor could a female figurine in a male burial be a representation of the deceased. Some progress could be made in the future if information of this kind can be obtained.

One fact that is clear is that only a minority of tombs contained figures. This may have been a matter of comparative wealth, since cheaper wooden versions could have been used in poorer burials. However, some graves rich in jewellery and other goods contained no figurines, so it is more likely that not all burials were assumed to 'need' them.

Various reasons could be suggested for this, perhaps connected with the status or occupation of the deceased. For example, if a man died before the age of marriage, a female 'substitute bride' might be considered necessary for him, while no such figure would be needed in the burial of an older man. An occupational connection might exist if the figures had been used in life for cult purposes and were buried

83 (*Far left*) Two complete figures and a head attributed to the Goulandris Master. Late Spedos type, about 2600–2400BC. (N.P. Goulandris Foundation, Museum of Cycladic and Ancient Greek Art, Athens, 256, 251 and 281)

84 (*Below*) Pregnant figurine of Late Spedos type (about 2600–2400BC) shown in the reclining position for which most Cycladic figures were designed. (GR 1932.10–18.1)

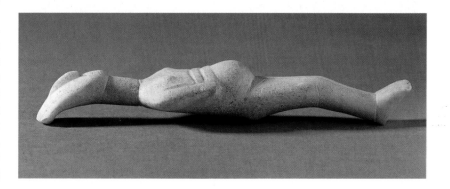

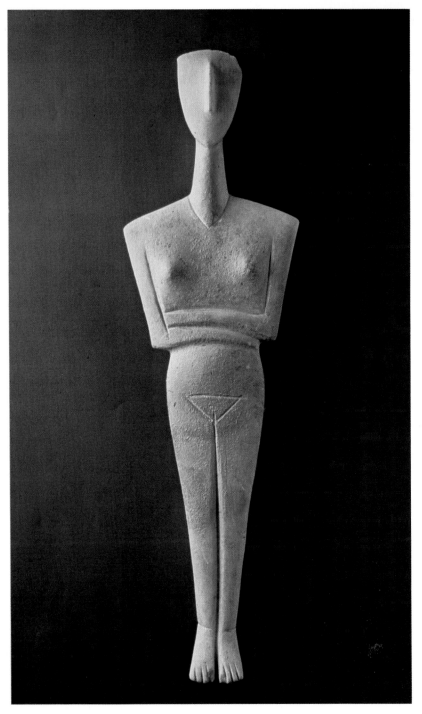

with someone who had a special function in the cult, such as a priest or priestess. At a simpler level, they might have been used in a small-scale domestic cult (and there is as yet little evidence for larger communal shrines or sanctuaries in the Cycladic world). Household shrines might have contained one or two figurines that eventually would be buried either with the person who administered the cult or perhaps with their dedicator.

This theory has recently attracted support and fits well with many of the facts. Firstly, fragments and complete figurines have been found in settlement sites, particularly at Phylakopi and Ayia Irini, though unfortunately not in very revealing contexts. Indeed, many had been disturbed and become mixed with later material. Even so, their presence in considerable numbers supports the theory that figures were in some way used in settlements, and this does seem to be borne out by the state of many recovered from graves, which are not only fragmentary but are actually missing parts or limbs which obviously were never put into the grave. Other figures from graves show signs of having been repaired.

It is, of course, possible to account for these things in other ways. Even if the figures were specially made for the grave, they might have spent some time in the settlements awaiting burial. Breakages might have occurred during the carving process and the figures mended before they left the sculptor's workshop. The ritual breaking of figurines and the discarding of certain parts is another possibility.

The theory that the figures were used in cult, then, can only be speculation, and remains to be proved. Certainly such cult usage would most probably be on a small scale, since

85 A beautifully preserved and very elegant female figure of Dokathismata type, dating from about 2500–2300 BC. (N.P. Goulandris Foundation, Museum of Cycladic and Ancient Greek Art, Athens, 206)

usually no more than two canonical 'folded-arm' figures are found together in a single grave – though these might be accompanied by musicians, as in the Keros grave discussed on p.42. The only possible evidence for larger-scale cult activity is offered by the curious site on Keros where hundreds of figurines and fragments have been found, but the status of this site is difficult to evaluate.

Even if the possible use of the figures in domestic cult is accepted, we still do not know what they represent. A female deity, perhaps with worshippers represented in her own image, is an attractive possibility. While the once-fashionable assumption that the prehistoric Aegean peoples worshipped a 'Great Mother' goddess is demonstrably simplistic, there can be no doubt that some explanation is needed to account for the fact that the majority of Cycladic figures are in the form of a naked female, and a female deity remains a possible identification. There is no exaggeration of female characteristics on the figures; in fact these are generally understated. The pregnant state of some of them naturally evokes notions of fertility, but it may equally have had individual relevance if the figures were believed to protect their owners at difficult times of life.

Any explanation of the figures must also account for the diversity of types represented. As well as the canonical female folded-arm figures, there are seated females and group compositions, including several instances where a small female stands on the head of a larger one. Male figures are represented in a variety of ways. Some are unadorned; some bear the attributes of hunter-warriors; some are shown in group compositions; others are

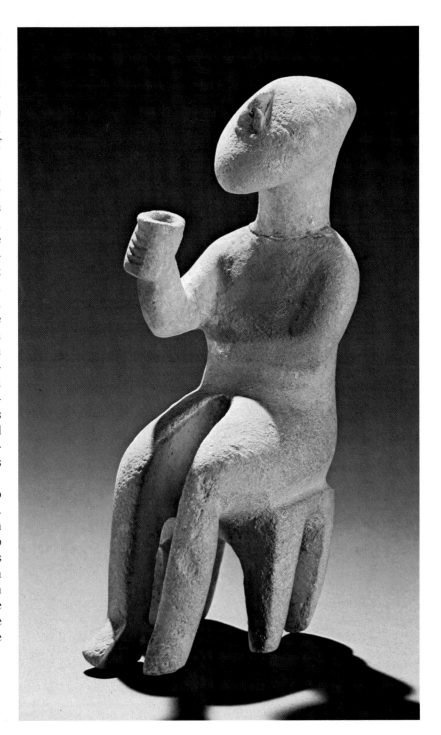

86 A masterpiece of Early Cycladic sculpture: a seated figure lifting a cup, as if proposing a toast. About 2700–2500BC. (N.P. Goulandris Foundation, Museum of Cycladic and Ancient Greek Art, Athens, 286)

38, 48 engaged in activities such as playing harps or
47, 86 pipes, or proposing a toast.

Some of these types would seem appropriate as dedications in a shrine: musicians might well play in honour of a deity, hunter-warriors might pursue their activities in honour of, or under the protection of, the god, and so on. Others perhaps seem more likely to be representations of a deity. Seated figures may come into this category: gods are more likely to sit amongst mortals than worshippers are to sit in the presence of a god. It has recently been
87 suggested that the very large figures – at least the few that approach life-size – might have been cult statues, meaning statues representing the deity which were the focus of cult activity, receiving worship, prayers and offerings. One argument in support of this idea is that none of the large statues is known certainly to have come from a tomb, though the suggestion has been made that they were broken into pieces in order to fit into the restricted space of a Cycladic grave.

Again, the lack of context means that any suggestions can only be hypothetical, but it has been pointed out that ears are more
front
cover frequently found on large figures. If this was not simply due to unrestricted space, or the individual sculptor's preference, then it might be that ears were appropriate in a statue designed to listen to prayers.

We must end where we began, with the admission that at present there can be no certainty about the significance or function of the figures. However, there is hope for the future. Further excavation of both settlements and cemeteries may throw valuable light on their original associations. We may never know the full story, but information obtained from the proper excavation of just a few figures in their original contexts could revolutionise our knowledge, helping us to understand their hundreds of 'orphaned' sisters (and brothers) in museums and collections all over the world.

Further reading

R. L. N. Barber, *The Cyclades in the Bronze Age* (London 1987).

C. Doumas, *Early Bronze Age Burial Habits in the Cyclades* (Göteborg 1977).

C. Doumas, *Cycladic Art: The N. P. Goulandris Collection* (London 1983).

J. L. Fitton (ed.), *Cycladica. Studies in Memory of N. P. Goulandris* (London 1984).

P. Getz-Preziosi, *Early Cycladic Sculpture: An Introduction* (Malibu, California 1985).

P. Getz-Preziosi, *Sculptors of the Cyclades: Individual and Tradition in the Third Millennium BC* (Ann Arbor, Michigan 1987).

P. Getz-Preziosi, *Early Cycladic Art in North American Collections* (Richmond, Virginia 1987).

G. Papathanassopoulos, *Neolithic and Cycladic Civilization* (Athens 1981).

A. C. Renfrew, *The Emergence of Civilisation: The Cyclades and the Aegean in the Third Millennium BC* (London 1972).

J. Thimme (ed.), *Art and Culture of the Cyclades* (Karlsruhe 1977).

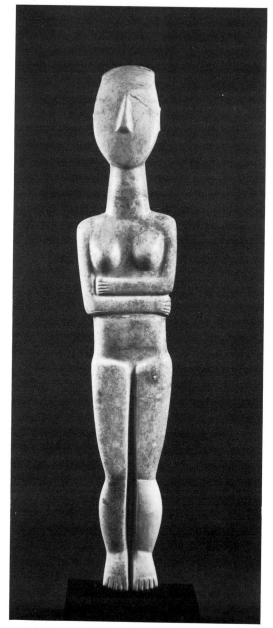

87 Marble figure of Early Spedos type (about 2700–2500BC). It is 140 cm in length and thus the second largest complete figure now known; details include incised fingers and carved ears. (N.P. Goulandris Foundation, Museum of Cycladic and Ancient Greek Art, Athens, 724)

Acknowledgements

A general work such as this is bound to owe much to previous publications that cannot be acknowledged individually, though such debts are at least partly revealed by the 'Further reading' list. I would particularly like to thank Dr Pat Getz-Preziosi, whose work underpins so much that is written about Cycladic sculpture, for very kindly reading a draft of the text and responding with her customary (and infectious) enthusiasm, as well as with a number of suggestions that have greatly improved the finished product. Dr Susan Woodford also generously gave up her time to read the text, and her sharp appreciation of what such a book should aim to achieve resulted in suggestions that I have gratefully incorporated.

Many colleagues in the Greek and Roman Department of the British Museum have given help and advice. I must thank particularly Mr B. F. Cook, Dr Veronica Tatton-Brown and Dr Lucilla Burn. My job-sharing 'other half', Ms Louise Schofield, has been kindness itself in a variety of ways, from swapping working hours to advising on academic points.

I would like to thank Miss Sue Bird for the drawings, diagrams and chronological chart, and Mr P. E. Nicholls and Mrs C. Graham for the photographs. I am also indebted to Ms Celia Clear and Ms Nina Shandloff of British Museum Publications for a happy collaboration.

Professors C. Doumas and C. Renfrew kindly allowed me to use photographs belonging to them, as did Mrs Dolly Goulandris. To her I owe an even greater debt: the visit of the Goulandris Collection to the British Museum in 1983 first allowed me some real insight into the Early Cycladic world, and I am very pleased to be able to illustrate here some of the finest pieces from that collection.

This book would not have been written without the support of my family, and I would like to thank John, Rebecca, Stephanie, Valerie, Susan and Richard. My parents, as ever, provided every sort of help and encouragement, and it is to them that this book is affectionately dedicated.

Photo acknowledgements

Lesley Fitton inside front cover, contents page, 3, 4, 5, 6
Courtesy of the Visitors of the Ashmolean Museum, Oxford 2
Christos Doumas 10, 28
Metropolitan Museum of Art, New York, Rogers Fund, 1945 (45.11.18) 21; Rogers Fund, 1947 (47.100.1) 38; Bequest of Walter C. Baker, 1971 (1972.118.103) 63; Purchase, Joseph Pulitzer Bequest, 1946, and Bequest of Walter C. Baker, 1971 (46.11.1 and 1972.118.152) 74
Colin Renfrew 26
National Museum, Athens 47, 48
Mrs Dolly Goulandris 66, 78, 83, 85, 86, 87

All other photographs provided by the British Museum Photographic Service.

Index

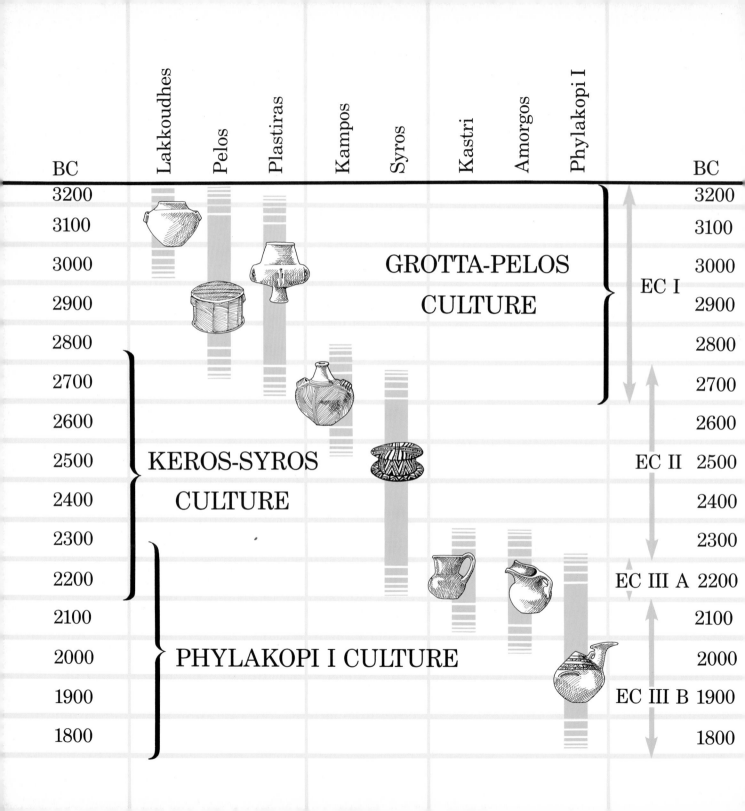

BC	Lakkoudhes	Pelos	Plastiras	Kampos	Syros	Kastri	Amorgos	Phylakopi I		BC

GROTTA-PELOS
CULTURE
EC I

KEROS-SYROS
CULTURE
EC II

PHYLAKOPI I CULTURE
EC III A
EC III B

BC	BC
3200	3200
3100	3100
3000	3000
2900	2900
2800	2800
2700	2700
2600	2600
2500	2500
2400	2400
2300	2300
2200	2200
2100	2100
2000	2000
1900	1900
1800	1800